This book belongs to

Pat Atkin

CLASSIC STONEWARE OF JAPAN

CLASSIC STONEWARE OF JAPAN

SHINO AND ORIBE

RYOJI KURODA
TAKESHI MURAYAMA

KODANSHA INTERNATIONAL
Tokyo · New York · London

FRONT JACKET: Shino teabowl named *Furisode*. Tokyo National Museum (above).
 Oribe square plate. Tokyo National Museum.
BACK JACKET: Picture Shino, small serving dishes (above).
 Fan-shaped lidded dish.

Previously published separately as *Shino* (© 1984) and *Oribe* (© 1982).

Translated by Robert N. Huey (Shino) and Lynne E. Riggs (Oribe).

Distributed in the United States by Kodansha America, Inc., 575 Lexington Avenue, New York, New York, 10022, and in the United Kingdom and continental Europe by Kodansha Europe Ltd., 95 Aldwych, London WC2B 4JF.

Published by Kodansha International Ltd., 17-14 Otowa 1-chome, Bunkyo-ku, Tokyo 112-8652 and Kodansha America, Inc.

Copyright © 2002 by Kodansha International Ltd.
All rights reserved.
Printed in Japan.
Combined edition, 2002.
02 03 04 05 10 9 8 7 6 5 4 3 2 1
ISBN 4-7700-2897-0

www.thejapanpage.com

CONTENTS

SHINO WARE — 7
 The Origine of Shino 8
 Early Influences—Momoyama Period 12
 The Beauty of Shino 14
 Shino Kilns 18
 Types of Shino 19
 Shino Clays; Shino Glazes 22
 The Value of Tea Ceramics and Shino Ware 23
 Modern Shino Potters 25
 Shino Miscellany 28

ORIBE POTTERY — 31
 Oribe in the History of Japanese Ceramics 32
 Furuta Oribe 34
 Mino Pottery 38
 The Varieties and Techniques of Oribe 40
 Types of Vessels 44
 The Oribe Kilns 46
 Mutual Influence between Oribe and Karatsu 48
 Oribe's Interest in Western Things 50
 Conclusion 50

PLATES — 53
 Shino 53
 Oribe 73

PLATE NOTES — 93
 Shino 93
 Oribe 103

Mino Kiln Sites for Shino Ware 111
Mino Kiln Sites for Oribe Pottery 112

SHINO WARE

THE ORIGIN OF SHINO

Until the advent of Shino ware, no white-glazed pottery was made in Japan. The Momoyama period (1573–1615) was an age dominated by the tea ceremony, an age in which great tea masters—Takeno Jōō, Sen no Rikyū, Furuta Oribe—appeared on the scene, setting standards of taste and demanding a steady supply of tea ceramics. They were enthusiastic about Shino ware, with its soft, white glaze.

These tea masters are indeed praiseworthy as arbiters of the tea ceremony aesthetic, but one cannot help admiring as well the artistic sensitivity of the artisans who actually created the pottery. The kilns where they worked were founded at Ōgaya by Katō Genjūrō Kagenari, and at the village of Kujiri by Katō Kagenobu. This mountainous region is not particularly isolated, yet something of the past lingers there today. These places still retain their heritage as pottery villages.

It is impossible to draw a clear line between Shino ware and Oribe ware, though one may say that the primary Shino glaze is feldspathic, while Oribe ware is known for its use of copper green and iron brown. Yet it is fashionable these days to distinguish the two wares, so that practice will be followed here.

The effect of the flames of the kiln on pottery is sometimes different from the one intended. In the semiunderground kiln—the type of kiln in which Shino was traditionally fired—much heat is lost. If the fire is not kept burning for a long time, the kiln will not reach the 12,000°C necessary. For many reasons, red pine is the best fuel for firing such kilns. The struggle to reach the high temperature necessary may last for several days, and it is no wonder that potters offer prayers to the gods of the kiln.

Each time I visit the old kiln sites at Mino I am deeply moved. I envision the potters going back and forth bearing loads of firewood. I can imagine their joy when the kiln is ready to be unloaded, and even more their despair if the firing proved a failure. Deep in the mountains of Mino things are as they have always been. In the spring the plum trees blossom, and violets bloom along the paths. In summer, the irises and water lilies are out. In autumn,

pampas grass plumes appear just about the time the bush clover is putting out its graceful flowers, and the wild grapes are turning color. Persimmons have been strung to dry from the eaves of a mountain house; their shadows are silhouetted on the translucent shoji screens. In winter, if a wood thrush comes to pay a call, it is caught in a fine mesh bird net. All of these subjects were given lively expression at the hands of the potters who decorated Shino and Oribe ware.

THE ORIGIN OF SHINO

Under the Ashikaga shoguns, Muromachi period culture was given direction by three great masters—Zeami, Nōami, and Geiami. Following them came Shino Sōshin (1444–1523), revered as a pioneer in the art of incense and reputed to be a discerning tea master as well. In his time, aristocrats and those surrounding the imperial family amused themselves with such elegant contests as trying to guess the type of incense by its smell or the origin of a tea by its taste.

There is a theory that Shino ware was inspired by a white Chinese teabowl in Sōshin's possession. Another theory has it that the name came from a tea caddy called "Bamboo Grass" (also pronounced *shino* in Japanese) owned by Sōshin. There are a number of other explanations as well.

The following entries appear in a tea ceremony chronicle covering the year 1716: "white Shino ware," "a water container of Shino ware," "a Shino ware tea caddy," and "a tea caddy of Shino Oribe." It would seem then that the term "Shino" came into use around the first decade of the eighteenth century. It is easy to understand the excitement felt by Momoyama period tea ceremony connoisseurs when they first laid eyes on Shino's white glaze.

Leaving aside the traditional theory that Shino ware came about when potters in the Seto region were commissioned by Shino Sōshin to make pieces to his taste, we turn to the *Honchō tōki kōshō* ("An Examination of the Pottery of Our Land"), written by Kanamori Tokusui in 1857, for a more complete examination. Kanamori consulted a variety of sources in compiling this work. Part of the section on Shino ware reads as follows:

"Shino Sōshin had a favorite white-glazed, 'shoe-shaped' bowl, imported from South Asia, which he used as a teabowl. This bowl is said to have been owned later by Imai Sōkyū (1520–93)." The *Meibutsuki* ("Record of Famous Products"—1660) states that Shino teabowls originated in Owari Province (present-day Aichi Prefecture) as imitations of this bowl. In fact, Shino teabowls closely resemble pottery from southern China and South Asia, and can usually be distinguished from the latter only by close examination of the clay.

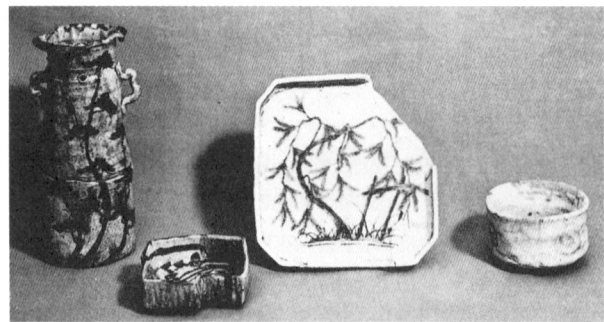

From right to left:
Shino teabowl; Shino Oribe dish; Oribe small serving dish; Mino-Karatsu ware flower vase.

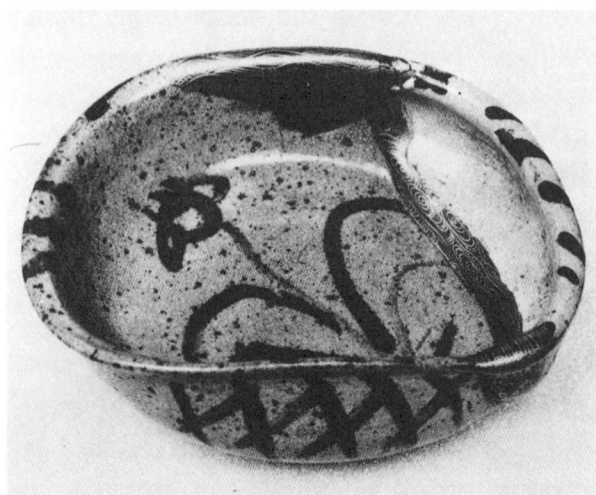

Picture Karatsu small serving dish. The pots pictured show the close affinity of Karatsu, Shino, and Oribe wares.

Shino ware, Oribe ware, and "Picture" *(e)* Karatsu ware are difficult to tell apart. Indeed, they are often simply called "Shino Oribe."

Shino ware is made in various styles, sizes, and qualities. Among the many kinds of Shino teabowls, good and bad, ones with a reddish tinge are highly prized. There is also a kind of Shino called "Plain Shino" *(muji Shino),* which is unpatterned but often has a reddish tinge. Even among pieces of this type, there is a great deal of variety. Some of these pieces have been fired very hard, and their glaze is a pure white with no hint of red. All Shino ware appears rather soft, but it is actually quite hard. There are a few examples of Shino teabowls with pictures on them.

Ken'ichirō Ono's 1932 history and lineage of the kilns at Mino, called *Owari no hana* ("Owari Flowers") has this to say about Shino: "In the first month of 1574, Kagemitsu, third son of Kageharu of the thirteenth generation after the first Seto potter Katō Kagemasa, moved to Akatsu. By virtue of a tea jar that he presented to the lord Oda Nobunaga, the latter formally recognized him as a retainer. Kagemitsu subsequently left Seto and moved to Kujiri, in Mino, in 1583. There he changed his name to Yōsanbei and continued working as a potter. He died in the eighth month of 1583 and was buried at Seian-ji temple."

About Kagemitsu's son Kagenobu, Ono says: "During the Tenshō era (1573–92) he moved to Kujiri to be with his father, and practiced pottery there."

"Under the tutelage of Mori Yoshiemon of Karatsu, in Hizen Province (Karatsu is in present-day Nagasaki Prefecture), he studied Karatsu kilns and later built a Karatsu style kiln himself in Mino. The quality of his work progressed rapidly, and he discovered a white glaze. He presented a teabowl he had made to Retired Emperor Ōgimachi. On the seventh day of the seventh month (late August) of 1597 he was given the title Chikugo no Kami, and he worked for Tsumaki Genban no Kami. He died in the second month (late March) of 1604."

These accounts would seem to give the most accurate descriptions of the origins of Shino ware.

EARLY INFLUENCES—MOMOYAMA PERIOD

The Momoyama period marks the division between Japan's medieval and late feudal ages. It was a time of vigorous artistic activity and an era when the fields of politics, Buddhism, painting, technology, building, landscape gardening, and so on, produced people of extraordinary talent.

The dominant imperial figure during this period was Ogimachi, who reigned first as emperor then later as retired emperor. The Takeda and Uesugi families were battling for control of the eastern provinces. Oda Nobunaga and Toyotomi Hideyoshi each had their days of rule. The prominent local military lords were Katagiri Katsumoto, Mōri Motonari, Tōdō Takatora, Gamō Ujisato, Tokugawa Ieyasu, and Date Masamune. Among the aristocrats at court, Ichijō Kanetaka and Konoe Sakihisa were in favor. Warlords such as Maeda Toshiie, Ukita Hideie, and Kobayakawa Takakage had their moments on the stage of history. It was an age when people were frantically taking what they could get at the expense of the nation.

This was also an age of superior men in other fields. At Daitoku-ji temple there was the priest Kokei Sōchin, to whom Hideyoshi and Sen no Rikyū turned for instruction, and the priest Shun'oku Sōen, said to have converted Nobunaga to Buddhism. Other outstanding figures included the famous master swordsmen Miyamoto Niten (also known as Miyamoto Musashi) and Tsukahara Bokuden, Hon'ami Kōetsu (the calligrapher, potter, tea master, and evaluator of swords), and the poet of Chinese verse Ishikawa Jōzan.

In the fields of calligraphy, Japanese poetry, and painting, there were such artists as Kaihō Yūshō, Kanō Eitoku, Hasegawa Tōhaku, Tawaraya Sōtatsu, Kusumi Morikage, Karasumaru Mitsuhiro, and Shōkadō Shōjō. The number of great figures in this age is truly astonishing.

It was also in the Momoyama period that Japanese pottery reached its peak. To be sure, this pottery did not just suddenly burst forth from nowhere. It had its roots in the Kamakura and Muromachi periods. But unquestionably, it was the commitment to culture of such powerful men as Nobunaga and Hideyoshi that nurtured this pottery and helped bring it into its own.

According to old pottery records, in 1563, during the rule of the shogun Ashikaga Yoshiteru, Oda Nobunaga made an inspection tour of his fiefs. At the time, he designated six potters from the Seto region of Owari as "the Six Artisans." They were Moemon, Chōjū, Shimbei, Shunhaku, Sōemon, and Ichizaemon. In fact, these six were not just potters. They seem also to have been aesthetes who traveled to and from the kilns at Seto and the cities of Kyoto and Osaka. Their identities are not absolutely clear. It has been established that there was a Shimbei who came from a merchant house in Kyoto at Yanagi no Bamba, who marked his work with a kiln mark in the shape of a capital letter "T" and who also made pottery at Bizen and Shigaraki. Pots bearing the "T" kiln mark are, without exception, skillfully made works. A green Oribe "shoe-shaped" teabowl in the author's possession has the "T" mark, and is indeed a fine piece, though one cannot say for sure whether the Shimbei who made it was the same Shimbei whom Nobunaga designated as one of the "Six Artisans" of Seto, since the name Shimbei was quite common.

Tōkurō Katō believes that the Shimbei who used the "T" kiln mark is probably the same person as the Shimbei honored by Nobunaga. But the possibility is also strong that the Shimbei who used the "T" kiln mark came from a family who ran an antique shop on Kyoto's Sanjō, for an old book says of this Shimbei that "he made excellent tea caddies."

Kanamori Tokusui, compiler of the above-mentioned *Honchō tōki kōshō,* and chief retainer of the Tamaru fief in Ise Province (in present-day Mie Prefecture), had a profound knowledge of tea ceremony as well as of antiques. The name Shimbei and the "T" kiln mark are mentioned in his book.

An earlier record of Seto's ten best potters was compiled by Furuta Oribe in 1585. This lists the following potters along with their kiln marks: Hanshichi, Rokubei, Kichiemon, Hachirōji, Sasuke, Motozō, Tomojū, Kinkurō, Jōhachi, and Jihei.

From the Momoyama period through the Edo period, Shino ware was without exception dominated by the Oribe taste. In fact, the entire range of Japanese pottery was influenced by each of the great tea masters in succession. Sen no Rikyū's preferred style held sway in the Tenchō, Bunroku, and Keichō

eras (1573–1615). Furuta Oribe's was preeminent in the Keichō and Genna eras (1596–1624). And Kobori Enshū's tastes prevailed from the Genna through the Kanbun eras (1615–73). After these three followed Katagiri Sekishū.

Of course, Shino and Oribe ware reflected the interests of Furuta Oribe. But Enshū after him favored works ordered from Korean kilns, and these imported pieces, in turn, had a strong impact on Japanese ceramics, as even a cursory look at such pottery will reveal.

Rikyū favored Setoguro and the Raku ware teabowls of Chōjirō. In addition, there was Rikyū Seto and Rikyū Shigaraki, which reflected that master's taste. Besides Seto and Mino, Oribe's influence was also strong at the kilns that made Karatsu ware. Indeed, one cannot help but admire the breadth of taste and influence seen in these great tea masters.

THE BEAUTY OF SHINO

The Azuchi-Momoyama period, dominated by the three statesmen, Nobunaga, Hideyoshi, and Ieyasu, was a transitional age between the tumultuous Muromachi period and the Edo period. Against the backdrop of various local lords continually going to war for their own gain, the Momoyama period nonetheless represented a new age for Japanese pottery.

There are thirty-some kilns scattered through the two counties of Kani and Toki in Mino. It is here that the purely Japanese wares of Setoguro (also called Tenshōguro or Hikidashiguro), Kiseto, Shino, Oribe, Mino-Iga, and so on, were first made.

To be sure, in the distant past there were kilns here as in every province, firing unglazed or ash-glazed folk pottery to meet the demand for everyday ware. Yet it is noteworthy that

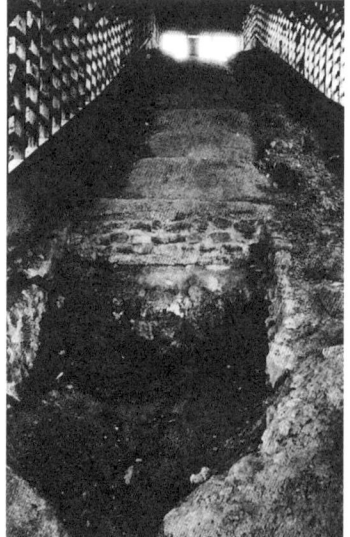

The old Motoyashiki kiln site at Kujiri.

in this area the potters broke free from tradition and began to experiment with new decorative techniques to suit the requirements of the tea ceremony. This was an important step.

The main reason behind this burst of creativity was the increasing demand for tea ceremony pottery. The development of ceramics at these kilns paralleled the growing popularity of the tea ceremony that revolved around Sen no Rikyū and Furuta Oribe.

In the past, merchants of the region were always going back and forth between Mino and the big cities of Kyoto, Osaka, and even Edo. Probably because of this, Kuguri, Ōhira, and Kujiri, being on the Kiso River and thus on the river trade route, prospered.

The founder of the Ōgaya kiln in Kuguri was Katō Genjūrō Kagenari. It is not certain exactly when he moved from Owari to Ōgaya, but it must have been sometime in the Tenshō era (1573–91)—about four hundred years ago.

Meanwhile, in Kyoto, the tea master Sen no Rikyū was commissioning works to his specifications from the first of the Raku potters, Chōjirō. Though

The old Kamashita kiln site at Ōgaya.

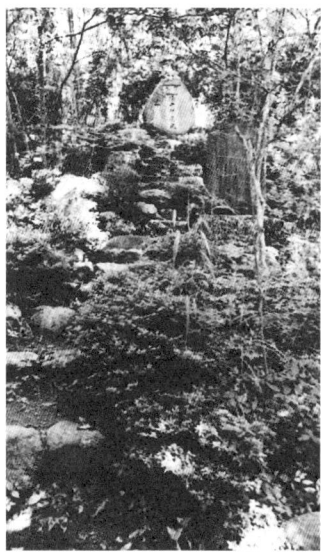

Memorial for Katō Genjūrō Kagenari.

the exact connection, if any, has been lost to history, Genjūrō Kagenari began firing black Setoguro teabowls similar to those produced by Chōjirō. The difference was that as a rule Chōjirō's teabowls tended to be small, while the Setoguro teabowls made in Mino were larger.

Kiseto and Shino ware, which were younger cousins of Setoguro, deviated from the standards set by Rikyū. They were more decorated, more consciously artistic. Rikyū dismissed them as "peculiar," but they unmistakably reflected the taste of Furuta Oribe.

Tōkurō Katō and the late Hajime Katō believe that it is wrong to make a distinction between Shino and Oribe ware. They maintain that Shino ware covered with a white feldspathic glaze should be called "White Oribe," while the ware decorated with copper green glaze should be called "Green Oribe." I agree.

Shino ware was so highly prized by tea masters and connoisseurs of old pottery because of the purity of its white surface, and its warm, quiet charm. The late Yasunari Kawabata, winner of the Nobel Prize for literature, was one who apparently felt drawn to Shino. He owned several famous Shino pieces himself, and a Shino teabowl figures prominently in his novel *The Thousand Cranes*.

I, too, must confess an abiding love for Shino ware. More than once my meager resources have gone into the purchase of a Shino piece. To me its charm lies in the feel of its surface and the mellow luster that accords so well with that surface. And there is the straightforward beauty of the pictures decorating Shino ware. The overall effect is intoxicating.

Shino pictures are drawn with lively lines depicting the everyday scenery surrounding the potters—the bridges over the streams at Kuguri, a cypress fence and dew-covered path leading to its brushwood gate, a grove of trees in flower, the trees and grasses just outside the window, even the mountain road they traveled day after day.

Such was the aesthetic of the Momoyama period in general. But the single tree, the few blades of grass these artists sketched are somehow pleasing because the designs pulse with life, the brushwork is clean and bold.

The white of Shino ware can be compared to that of the first snow of the season, or to the last traces of the winter snow, which the warm spring winds are erasing as the bush warbler's first song rings out. Shino's white surface is soft like a mother's breast; it brings back memories of childhood.

Shino white is tidiness itself. And on that white the potters painted designs with an iron glaze made of *oni-ita,* a red clay rich in iron and manganese and abundant in the Seto region. The effect of flame in the kiln added distinctive fire marks. Shino is an elusive ware, capable of infinite transformations.

The Shino potters thickly applied their glaze, which they made by carefully grinding feldspar and refining it in water. To this they added their own secret proportion of ash. Then, after offering saké and prayers to the gods of the kiln, and ritually scattering salt to purify the area, they entrusted their pieces to the fire.

Shino ware is the spirit of tea, the essence of pottery. It is the result of the flames of the kiln.

> In the depths of the heart
> From which pottery springs
> Flows a crystal clear stream
> Reflecting nearby mountains.
> —*Rosanjin Kitaōji*

Rosanjin wrote of Shino: "Among glazed Japanese pottery of the medieval period, the white of Shino ware is most unusual.... In the finest of Shino pieces, the design on the white glaze, or the brownish tinge that appears around the parts of the piece that have turned a pleasing red, are a delight to the eye."

Nowadays it is the ceremonial teabowls that are the most prized Shino ware, along with serving dishes, incense boxes, and *hi-ire* (ceramic cups used to hold glowing embers for lighting pipes). But these were not the only things made by the Shino potters.

SHINO KILNS

The major Shino kilns and their locations are as follows: the Kamashita, Mutabora, and Naka kilns of Ōgaya in present-day Kuguri-Ōgaya, Kani District, Kani County; the Yuemon and Inkyo kilns of Ōhira in present-day Ōhira, Kani District, Kani County; the Motoyashiki, Takane, and Shōbu kilns of Kujiri in present-day Kujiri, Izumi District, Toki City; the Ōtomi kiln in present-day Ōtomi, Izumi District, Toki City; the Jōrinji and Entogawa kilns of Jōrinji in present-day Jōrinji, Izumi District, Toki City; and the Kamashita kiln of Tsumaki in present-day Kamigō, Tsumaki District, Toki City. According to Tōkurō Katō, the kilns at Ōgaya were the earliest, followed by those at Kujiri, which were in full production from around the first quarter of the seventeenth century.

The Mutabora, Kamashita, and Naka kilns of Ōgaya were all in production at about the same time and were responsible for the best Shino pieces. The teabowl *U no Hanagaki* ("Fence of Deutzia Flowers"—Plates 2, 3) is an example of the work from these kilns. Their pieces were usually bold in execution, like the powerful water container named *Kogan* ("Weathered Shore"—Plate 1), now in the Hatakeyama Collection. Other striking examples from the Ōgaya Kamashita kiln include the teabowl *Mine no Momiji* ("Summit Maple Leaves"—Plates 14, 15), owned by the Gotō Art Museum, and the teabowl *Yama no Ha* ("Mountain Ridge"—Plate 10), owned by the Nezu Art Museum.

The Mutabora kiln of Ōgaya was known for its rectangular dishes with "picture frame" (*gakubuchi*) rims. To be sure, such pieces were also made at Ōhira and Kujiri kilns, but the bowls thought to come from Ōgaya are superior.

A close examination of the feet on the set of five undecorated saké cups shown in Plate 50 gives the strong impression that they were made by the same potters at the Ōgaya Kamashita kiln who made Kiseto ware. One is fascinated by the straightforward yet unexaggerated statement of the potter's wheel found in these cups.

Both the plain Shino saké bottle, unearthed at the Takane kiln site, and the saké bottle with design of willow branch (the two pieces are seen in Plate 9) are thick-walled and obviously made to be used. They appear to have been

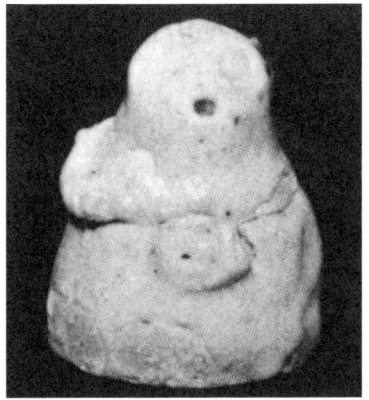
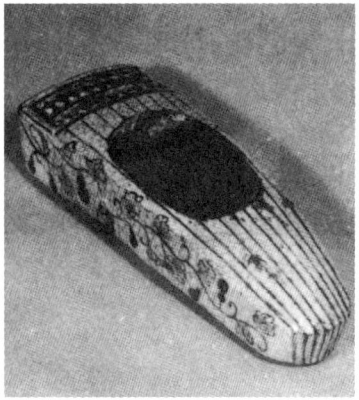

Monkey-shaped water dropper.　　　　Koto-shaped Shino Oribe inkstone.

made sometime in the first quarter of the seventeenth century, when Oribe taste was dominant.

It appears that from the Genna era (1615–24) onward, articles for daily use were fired alongside tea utensils at the linked-chamber climbing kiln at Motoyashiki. In addition to tea ware, lamp accessories, smoking utensils, a rare seal stamp, high-quality ceramic rests for ink sticks, many water droppers for measuring water onto the inkstone, and innumerable similar small items were fired there, but very few of them have the Shino glaze.

To be sure, not every Momoyama potter was a master. Yet the Gray *(nezumi)* Shino produced at Kujiri and Ōhira (particularly at the latter's Inkyo kiln) was of uniformly high quality. And pieces from the Takane kiln, like the incense box in Plate 41, show a bold, sturdy character somewhat different from the thin-walled pieces fired at Ōgaya.

The Motoyashiki kiln also produced many small saké cups with squared rims and squeezed-in sides. These cups are thick-walled and decorated with pictures of violets, pampas grass, cypress fence, water lilies, and so on. Beautiful color changes occurred inside them during the firing.

Hardly any writing accessories produced at the Shino kilns have been handed down—extant pieces are excavated objects. The monkey-shaped water dropper unearthed at Ōgaya shows beautiful craftsmanship and a sweet charm comparable to the ancient figures. There is also a Shino Oribe inkstone in the shape of a *koto*. This piece used to be in my possession, but it has since passed into other hands. It is of the highest standard and truly unusual.

TYPES OF SHINO

Plain Shino (muji Shino)
This is solid white Shino ware with no deliberate patterns or pictures. A red

color is often produced at the lip or at the corners of the pot where the iron content of the clay or the underglaze is only thinly covered by the feldspathic overglaze. Plain Shino was most common in the early period of Shino's history, but gradually came to be supplanted by decorated Shino. By the Genna era (1615–24), few plain Shino pieces were being made.

PICTURE SHINO (e-Shino)
Pictures are painted on the formed pot with a pigment made of the iron-and-manganese-rich *oni-ita* clay found in the region. Feldspathic glaze is then applied over the picture. The result is a black, red, or purple design that seems to float faintly up through the glaze.

Most favored were designs of grasses and flowers, fences, mountains, and

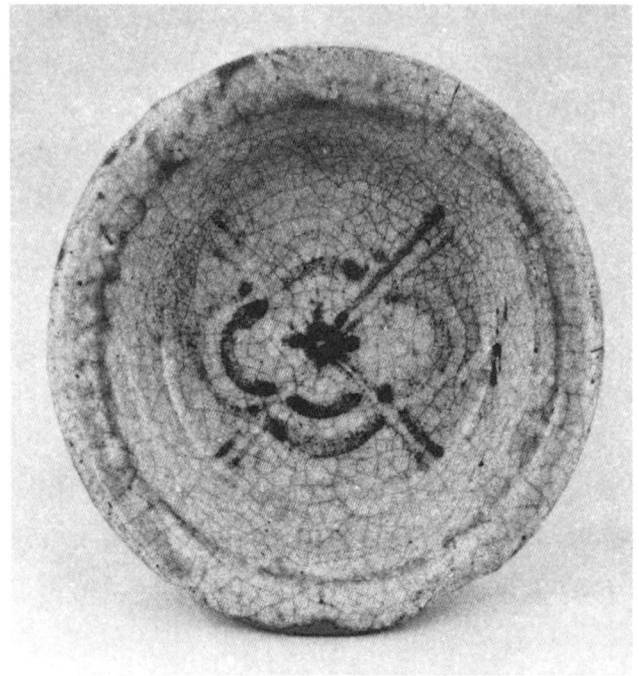

Picture Shino plate, cross design.

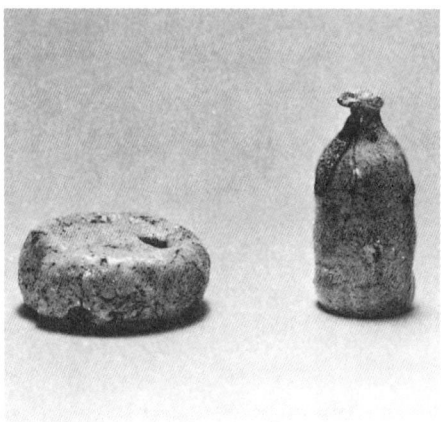

Miniature saké bottle and ink stick rest.

geometric patterns. Christian influence can be recognized in the cross patterns occasionally used. In a few unusual cases, phrases from poems were painted on.
SHINO ORIBE: Shino Oribe is hard to separate from Picture Shino. The glaze of the former is perhaps a little thinner. The distinction is mainly chronological, with Shino Oribe being produced from the Genna era (1615–24) onward. If pressed to distinguish between the two, one might say the glaze of Shino Oribe shows a more pronounced shading of light and dark.

CRIMSON SHINO (beni Shino)
A slip made of red clay is used for decorating the surface of the pot. Over it a thin layer of feldspathic glaze is applied. The red that emerges in the firing is the same as that of Red Shino (see below), but the materials are different. Crimson Shino calls to mind a poem by the haiku poet Kyoshi:

> The white peony
> Or so it's called, and yet
> Crimson floats there faintly.

RED SHINO (aka Shino)
This is actually Gray Shino (see below) that has fired red because the feldspathic overglaze is thin and the kiln atmosphere has affected the iron-rich slip.

GRAY SHINO (nezumi Shino)
A slip of *oni-ita* clay is thickly applied to the surface of the pot, then a design is incised into it using a pointed bamboo or metal tool. The entire pot is then covered with feldspathic glaze. After firing, the pattern shows white, while the overglaze is gray. Occasionally the gray will have a faint purplish tinge—a highly-prized effect.

MARBLED SHINO (neriage Shino)
This technique is found only in teabowls from the Mutabora kiln at Ōgaya, and then only rarely. Even potsherds of this type are scarce. White clay and

red clay are lightly mixed before throwing. After firing, the two types of clay show as white and black layers under the feldspathic glaze.

This technique was already being practiced in Tang and Song China. It is also found among pots from the Koryō dynasty in Korea, and this may have been the source for the Shino potters.

White Tenmoku (shiro tenmoku)
This might be thought of as "pre-Shino Shino." Two White *Tenmoku* pieces said to have been originally owned by the tea master Takeno Jōō have been passed down through the Owari branch of the Tokugawa family and the Maeda family of Kaga. Both of the bowls have two or more ridges up through the body. The bowl in Plate 19 belongs to the author and was excavated in the vicinity of the Ōhira kiln. It might well be called Shino *tenmoku*.

SHINO CLAYS; SHINO GLAZES

"Shino is the rough white clay of Mino; its glaze is pure feldspar to which a touch of silicic acid has been added." So says Tōkurō Katō.

"To make the Shino glaze, bars of weathered feldspar are ground into powder, then sifted. To this is added ash, clay, and a small amount of salt. Since this glaze does not adhere easily to clay, it is best to soak the pot thoroughly in it." This is Tōkurō Katō's description.

Toyozō Arakawa says, "The clay is wedged thoroughly. The materials for the glaze are carefully ground into powder with a water mill. In the old days, the grinding was done by a foot- or water-powered mortar or by pounding with an oak mallet. The *oni-ita* clay used for the designs was also crushed by hand. A bit of silica-rich ash was added to the feldspar to make glaze. In the past, feldspar taken from the Kujiri region was used, but deposits of that mineral were scarce there. The mountains around Inkyo also yielded feldspar."

The late Hajime Katō (1900–68; designated a "Living National Treasure" in his lifetime) used to say that the feldspar from the Murakami area of Niigata Prefecture was best for Shino. And the late Kitaōji Rosanjin considered the

feldspar from Wakasa, along the northern shore of Lake Biwa in Fukui Prefecture, to be of such fine quality that he brought it himself from there to his kiln in Kamakura.

The clay used for Oribe Shino would be best characterized as "moxa-type." I once saw a twenty-centimeter-thick vein of it at the ruins of an old kiln near Ōhira where *yamajawan* (prototeabowls made during the Kamakura and Muromachi periods) were once fired. To potters, good clay is one of the secrets of good pottery, and they keep a hawk's eye out for it.

This was made clear to me some years ago when I was riding the newly inaugurated bullet express train with Tōkurō Katō. He was staring out the window, and as the train sped past the base of Mt. Fuji, near Shizuoka, he suddenly said, "Now *there* is some fine clay!" His eyes were fixed hard on a certain spot.

THE VALUE OF TEA CERAMICS AND SHINO WARE

While it is true that Kitaōji Rosanjin was known to have once planned a tea ceremony in which all of the utensils to be used were ones he had made himself, it is a general rule that the utensils chosen for a tea ceremony should not all be of the same kind. Thus even a tea host who is proud of his collection of Shino should not perform the ceremony using only Shino pieces. For example, if the ember holder in the ashtray in the guests' waiting area is made of Shino ware, then the water container or the teabowl used in the ceremony should be of some other ware, if one wishes to follow standard procedure. Since the combination of utensils used in a particular ceremony is taken to be representative of tea history and tea aesthetics, it is best to pick pieces that are suitable for the circumstances and not to be extravagant.

It would be a tea master's dream, perhaps, to use the teabowl named *U no Hanagaki* ("Fence of Deutzia Flowers"—Plates 2, 3) in a spring ceremony, or the teabowl *Yama no Ha* ("Mountain Ridge"—Plate 10) or *Mine no Momiji* ("Summit Maple Leaves"—Plates 14, 15) in an autumn ceremony. Yet to marshal an array of famous pieces would leave the guests hard pressed to make appropriate praise. When I am serving tea, I pay careful attention to the guests who

will come, and I try to select utensils accordingly. I give particular thought to whether any of my Shino treasures will be used for the tea ceremony or accompanying formal meal.

Perhaps one does not aspire to such a classic water container as *Kogan* ("Weathered Shore"—Plate 1); rather, one seeks a change of pace in a modern water container by, say, Toyozō Arakawa or Tōkurō Katō. But nowadays even the pieces of these great contemporary masters have become so valuable as to be practically unobtainable.

An incense burner is supposed to be of subdued design and is placed unobtrusively in a corner of the *tokonoma* (a special alcove in the tea room). Yet a celebrated Shino incense box, barely large enough to fill the palm of one's hand, might nowadays fetch up to $50,000.

In the formal meal accompanying a full-dress tea ceremony, small serving dishes called *mukōzune* play a central role. One such dish, if early Picture Shino or Gray Shino, can cost up to $10,000. Thus, a set of five—the usual number—would come to $50,000. Even a new Shino saké cup that would be used outside the tea ceremony can be sold for $3,000–$5,000. A classic piece is even more valuable.

The question is often asked, "Why are these utensils so expensive?" The only answer one can give is "All tea articles are expensive." These pieces are not expensive because they are tea ceramics. The fact is that all ceramics are in some sense tea ceramics, whether they be folk pottery or pottery of the highest technical virtuosity (for the talented tea master can make use of anything). But it is undeniable that ceramics having a specific relationship with the tea ceremony are especially expensive.

If we imagine for just a moment that such a piece as the *Mine no Momiji* teabowl were put on the market, it would easily fetch over $200,000, even in bad economic times. Ounce for ounce, such masterpieces are far more valuable than pure gold.

Simply stated, Shino ware is more expensive than Oribe ware, and Kiseto ware is more expensive than either one. Setoguro, while older as a pottery, is somewhat less valuable than Shino.

A piece of Shino, the price of which would have taken one aback ten years ago, will be worth three times that price not so many years from now. The cost of just one fine Shino teabowl is the same as that of a fine house.

MODERN SHINO POTTERS

In 1930, as Toyozō Arakawa was looking around old kiln sites at Mino, he found a Shino potsherd—a bit of a serving dish with a picture of a bamboo shoot painted on it. His discovery sparked a revolution in thinking about Momoyama pottery, for up to that time it had always been believed that Shino had only been made at the Seto kilns. Arakawa tells the story in his own words:

> The seeds for my discovery were sewn in the spring of 1930, when, through the good offices of Yokoyama Gorō of Nagoya, whose shop specialized in the finest tea ceremony articles, I was taken to the home of a certain wealthy family to view a Shino incense box and a Shino teabowl. There is no need to go into detail regarding the circumstances leading up to my seeing the teabowl, but at least some small description of the bowl would be in order. It was large and cylindrically shaped, as is often the case with Kiseto teabowls. A narrow *dōhimo* line had been pinched outward around

Clay quarry, Kani-machi.

Toyozō Arakawa's kiln.

the center. Soft, snowlike Shino glaze covered the entire pot, here thick, there thin. And in places a scarlet of rich tone had emerged naturally. Two bamboo shoots, one large and one small, had been artlessly painted onto the cylinder as if to illustrate the lines of the poem "on gently sloping mountainside/two or three pines." Inside the foot, there was a distorted red circle—the mark of a fireclay pad. It was a gentle pot, with a distinctly Japanese air.

Up until that time, I had always been enamored of Chinese or Korean pottery and had tried to emulate it. Of Japanese styles, I had only tried my hand at Old Kutani. But I was deeply moved by this peculiarly Japanese Shino bowl and I gazed long and hard at it as if to devour it with my eyes.

Suddenly my eye was caught by a tiny red speck barely half the size of a grain of rice. It was a bit of red clay stuck to the inside of the foot—a remnant from the fireclay ring. It had long been claimed that Shino ware had originally been fired at the kilns at Seto, in Owari, but this tiny bit of clay stuck to the Shino bowl did not seem to be the kind of clay one might find around Seto. Thus I began to have doubts about the tradition that Shino came from there.

That night I could not sleep as I turned these doubts and their implications over in my mind. I remembered how in 1923 or 1924 I had come from Kyoto to look into the old Mino kilns. Digging at the old kiln site at Ōhira, I had only found shards covered with black *tenmoku* or amber-colored iron glaze. On the way back, I had found a fragment of a green Oribe pot and, thinking it was an odd thing to find there, I had taken it home with me. Looking back on that, I began to wonder if maybe Shino ware had not actually been fired at Mino.

I felt I had to go there and find out as soon as possible. Waiting for the sun to come up was agony. Early the next morning, I took the first train to Tajimi, and since there were no cars in Tajimi in those days, I stayed the night there.

The next day, before dawn, I followed the directions a local man had given me and started out along a mountain road in Takada—the same

road I had walked some years before. After a mile or so I came to that same old kiln site, and I quickly began to dig. But again I only found bits of black *tenmoku* and amber-glazed shards. There was nothing even faintly resembling Shino.

I was a little disappointed, but the sun was still high in the sky, so I decided to go on to the kiln site at Ōgaya. I had never been beyond Ōhira before, but I followed the one road that led between the two mountains and after about two kilometers I arrived at Ōgaya. At Ōhira there were only four or five houses perched here and there on the mountainside, and the mood was quite lonely. But at Ōgaya, even though there were only five or six houses, too, tucked into the mountains, the atmosphere was bright and tranquil.

Having asked directions from an old villager, I made my way to what looked like an old kiln site in a forest of cedars and other trees in the valley of Mutabora. Sifting through the shards I discovered among the pieces of *tenmoku* black a shard with Shino glaze on it. Looking at it carefully I could hardly believe my eyes, for it was exactly like the teabowl I had seen two days earlier, even down to the design of bamboo shoots in red! Almost doubting my sanity, I continued to dig as though in a dream. Next I found a fragment of a large bowl done in what is commonly called "Gray Shino." Its glaze was just like that of the incense box I had been shown along with the teabowl. I realized that I had run across something very important indeed. I am afraid I am just not good enough with words to describe how I felt at that moment. From the *Sekai tōji zenshū* ("Pottery of the World"), Monthly Report 8.

Arakawa's discovery set off a spate of kiln excavations, first by Rosanjin Kitaōji and Tōkurō Katō. Soon thereafter, teams sponsored by major newspapers and led by such men as Ken'ichirō Ono, Kichijirō Inoue, and Nagatake Murayama also joined in. The pastures around Tajimi proved to be a treasure trove of valuable artifacts.

In recent years there has been a boom in the collecting of tea ceramics. For

this a debt is owed to the great masters Toyozō Arakawa and Tōkurō Katō and the hardships they endured before the war in their pursuit of Momoyama pottery.

The dramatic rise in demand for tea ceremony ceramics has been a blessing for potters. Shino ware has proved particularly popular, and now over one hundred potters make this ware.

Space limitations have prevented discussion of more than the work of a few potters in these pages, yet the scale of the Shino operation is quite large. Starting with the village of Akatsu, favored by artisans in the 1910s and 1920s, potters are concentrated in a wide bank centering on Tajimi, where many of the Momoyama and Edo period kilns used to be. In terms of size, this "pottery village" far surpasses the much vaunted one at Seto.

At Mutabora in Ōgaya a group of potters working in the traditional style has gathered under the leadership of Toyozō Arakawa. Using a traditional semiunderground kiln that they built themselves, this group truly represents a modern Momoyama revival.

In contrast to the nameless potters of old, who probably led a hand-to-mouth existence, many present-day artisans are strikingly wealthy. Tōkurō Katō has wryly noted that "what potters of today create is homes for themselves."

Nevertheless, there remain many potters of good faith. For their sake it is sad that there are so many undiscriminating people who like anything called Shino regardless of what it is or who made it.

SHINO MISCELLANY

The piece named *U no Hanagaki* ("Fence of Deutzia Flowers"—Plates 2, 3) is considered the finest of all Shino teabowls. Others include: *Asahagi* ("Morning Bush Clover"), *Asahi* ("Morning Sun"), *Mine no Momiji* ("Summit Maple Leaves"—Plates 14, 15*)*, *Yama no Ha* ("Mountain Ridge"—Plate 10), *Sazanami*

("Ripples"), *Hatsune* ("The Bush Warbler's First Spring Song"), *Hirosawa* ("Wide Marsh"), *Yūmonji* ("Evening Maple Leaves"), *Sumiyoshi* ("Sumiyoshi"; a place name), *Tsūten* ("The Maple Leaves at Tsūten Bridge"), *Kasugano* ("The Field at Kasuga"), *Hashihime* ("The Lady at the Bridge in Moonlight"), *Senkoku* ("One Thousand Measures of Rice"), *Hagoromo* ("Feather Cloak"—Plate 18), *Mōko* ("Fierce Tiger"), *Ushiwaka* ("Young Minamoto no Yoshitsune"), *Yokogumo* ("Bank of Clouds"), *Matsushima* ("Pine Islands"—Plate 21), and *Asahikaga* ("Morning Sunlight"). These and other fine bowls are hidden away in the mansions of famous collectors of tea ceramics, and rarely is there opportunity to see them.

The complete teabowl experience can only be had by actually holding the bowl in the palm of one's hand and putting one's lips to its rim to drink the tea. Though this experience has been written about in countless books, it can never be completely described. The pleasure it brings is like a dream.

I have had the chance to see firsthand the teabowls *U no Hanagaki* and *Mine no Momiji,* and I shall never forget the powerful emotions I felt at the time.

The *Taishō meikikan* ("Famous Ceramics of the Taishō Period") says this about *U no Hanagaki:* "Its lip is rounded at the rim and even in thickness. A reddish tinge suffuses the white glaze that covers the entire body. Dark crosshatches have been faintly drawn on the sides in a manner that suggests a woven fence. Cloud-white glaze surrounds and partially obscures this design, giving the impression of white deutzia blossoms—hence the name, "Fence of Deutzia Flowers."

The book goes on to say, "The grace of this deep teabowl is eloquent testimony to the skills of the potter who made it."

The teabowl *Hatsune* ("The Bush Warbler's First Spring Song") was once featured at a lecture given by a local chapter of the Nihon Tōji Kyōkai (Japan Pottery Association). The firing of this bowl produced a subtle, plum-red cast on the white surface. Looking at it, one could almost hear the first spring song of a bush warbler perched on a plum branch. Nowadays, this teabowl would never be lent out to some regional group, but until 1955 such a thing was conceivable.

Around 1965, the teabowl *Mine no Momiji* was put on display. We were not allowed to touch the bowl, which was set on a purple cloth, but we could see it from all four sides. The restrictions placed on the viewing were cruel indeed, for to feel that bowl resting in the palm of one's hand surely would have been a more meaningful encounter with Truth. It was like having an itch one could not scratch.

In my own collection there is a cylindrical serving dish with willow and bush clover design, made at the Ōgaya kilns (see Plate 26). I discovered one just like it at an inn called Nandaimon in Nara. The owner of that inn, the father of an old acquaintance of mine, made a practice of displaying his favorite art possessions in the lobby of the establishment, and it was there that I saw the dish exactly like mine.

Supposing those pieces were made around 1605, what joys and sorrows, what vicissitudes, must these two pots have seen since they left the Ōgaya kilns some 380 years ago. The innkeeper and I passed hours in such speculation. For all that they must have passed through, these pots seemed none the worse for it.

We wondered if the innkeeper's pot looked the way it did precisely because it had been through good times and bad. Or perhaps, we conjectured, it might have benefited from supernatural protection, or the loving attention of some tea master.

In the case of my serving dish, I know that it was kept by several tea masters in Kanazawa and did not see much of Edo period Japan. But the innkeeper's pot—what kind of journey did it make through history? And what will happen to it in the future? Such are the emotions, the feelings of attachment, that a single Shino piece can generate.

ORIBE POTTERY

ORIBE IN THE HISTORY OF JAPANESE CERAMICS

The first ceramics to be used in the Japanese world of tea ceremony were *tenmoku* teabowls brought from China by Zen monks and celadon flower vases and water containers brought by trading vessels from Southern Sung China. As was fitting to the ostentatious style of the tea ceremony of the Higashiyama period (late sixteenth century), the paintings and other art objects displayed were all imported from China.

The father of the modern tea ceremony, Murata Shukō, put aside the costly and excessively formal pieces from China in favor of a more somber taste, using much more humble utensils for drinking tea. A look at the subdued color of the celadon teabowl we today call Shukō celadon gives us some notion of the ideals he sought to establish in the tea ceremony. The tea of Takeno Jōō took this aesthetic one step further by encouraging the asceticism—the "cold and withered"—of what came to be known as *wabi-cha*. He used everyday bowls made by anonymous potters of Yi dynasty Korea to introduce the spirit of simplicity to the tearoom.

The aesthetic of *wabi-cha* was further refined and perfected by Jōō's student Sen no Rikyū, who asserted that the tea ceremony should be unpretentious— "simply boiling water and drinking a cup of tea." Rikyū sought to instill a religious aspect in the tea ceremony. In order to give concrete form to the ideals he sought, he determined to make a teabowl expressly his own. He commissioned the head of the Raku family of potters, Chōjirō, for the task, and the first Raku teabowls were made. As Rikyū had stipulated, they were modestly shaped and focused inward. His specific choice of black for the teabowl, too, was intended to symbolize the meditative spirit of tea he taught. Indeed, this type of teabowl is an eloquent symbol of the medieval quality of mystic search.

At the dawn of the Edo period, after Rikyū's death (1591), one of the leading masters of tea was Furuta Oribe, distinguished general of that strife-torn period. It was only natural that the taste of Oribe's time should favor tea utensils that were robust, generous, vigorous, and distorted in shape. And to

the simple philosophy of drinking tea that Rikyū had taught, the tea men of that time, with Oribe at their head, added the pleasures of companionable eating and drinking. To meet the expanded needs of their tea and dinner parties, eating and drinking utensils, including serving dishes, covered dishes, saké bottles, and saké cups, became necessary. These utensils began to be made at the Oribe kilns, and at Karatsu, Agano, and Takatori, and all were drawn together by the governing taste of Furuta Oribe. The pieces that were produced were typical of the flowering of craftsmanship that was part of the renaissance of art that occurred in the Momoyama period (1573–1615), brightly colored and gaily decorated in original and creative ways. The rustic character of the provincial warrior was, so to speak, tamed and refined in the flow of time, flowering magnificently in the Momoyama period.

Pottery that was artlessly made could attain a strength of character not present in the carefully and skillfully worked, revealing the unadorned essence of the material. Quite apart from the earlier lineage of Mino pottery, the magnificent Oribe designs are plainly the outgrowth of the tremendous cultural wealth of the Momoyama period.

After Oribe's death, as the feudal system of the Tokugawa shogunate became established, peace and stability settled over the country. The dynamic, creative Oribe pottery gradually faded into the shadows. And succeeding "Oribe taste" was "Enshū taste," established by the tea master Kobori Enshū (1579–1647). With this new aesthetic trend, the pottery that enjoyed greatest popularity was the finely built, delicately glazed works of the so-called Seven Kilns that Enshū supervised.

With the middle Edo period, this aesthetic gave way in turn to the more ostentatious aristocratic tastes preferred by Kanamori Sowa and his contemporaries, as typified by the pottery of Nonomura Ninsei. Toward the end of the Edo period, Japan's leaders in aesthetic taste, including Mokubei and Nin'ami, began to lose interest in the traditional tea ceremony centered around powdered tea *(matcha)* and to turn instead to the esoteric, literati preferences of *sencha* connoisseurship.

FURUTA ORIBE

"Oribe" most commonly refers to the type of Mino pottery characterized by the presence of green glaze. In fact, however, the term may be interpreted as encompassing all the Mino wares—Shino, Yellow Seto, as well as Oribe in the strict sense—because they belong to what is known as "*Oribe-gonomi,*" that is, they were liked and chosen by the great tea master Furuta Oribe (1544–1615). Also, Oribe ware using green glaze containing copper may be called Oribe in a very narrow sense. Of course, Oribe also refers to the man—Furuta Oribe himself.

Oribe was born in a wealthy landowning family of Mino. His grandfather Minbu and father, Shigesada, had served the local Toki and Saitō clans through two generations. Oribe, however, was a retainer of Oda Nobunaga (1534–82), later Toyotomi Hideyoshi (1536–98), and finally Tokugawa Ieyasu (1542–1616), thus serving the three most powerful figures in the turbulent period that bridged medieval and premodern times in Japanese history.

As a child, Oribe was called Sasuke or Kosa; his first name as an adult was Kageyasu, and he was later known as Furuta Oribe no Shō Shigenari or simply Koori (a shortened form, taking the first characters of his family and given names).

After Nobunaga died in 1582, Oribe distinguished himself under Toyotomi Hideyoshi in the battles of Yamazaki (1582), Shizugatake (1583), Komaki, the capture of Kishū (present-day Wakayama and Mie prefectures), and in other ways, earning the title Oribe no Shō of the lower fifth rank and receiving the fief of Nishigaoka of the province of Yamashiro (in the present-day metropolitan area of Kyoto) with a value of 35,000 *koku.* He was singled out to join the group of Hideyoshi's close confidants known as the *otogishū,* and after Hideyoshi's death devoted himself to the tea ceremony at his residence in Fushimi. It appears that Oribe was famous as a master of the tea ceremony at that time, for in the March 22, 1599, entry of the *Tamon-in nikki,* the diary of the abbot of the Kōfuku-ji temple, it is recorded that "The prominent tea master Oribe came from Fushimi." At this time Oribe had already handed over his

35,000 *koku* fief in Yamashiro to his heir, Shigehiro, keeping lands of only 3,000 that had belonged to his father for himself. In 1600 during the Battle at Sekigahara, he again performed meritorious service in successfully taking a hostage from the lord of Hitachi, Satake Yoshinobu, and this brought him a reward from the Tokugawa of land worth 7,000 *koku* in the province of Ōmi, giving him territories totaling 10,000 *koku*.

As Tokugawa Ieyasu launched his winter offensive against the remaining Toyotomi forces at Osaka Castle in November 1614, Oribe and his son Shigehiro supported the Tokugawa side, and Oribe was wounded by a stray bullet. However, his youngest son, Kuhachirō, who was a page in the service of Toyotomi Hideyori, was suspected of passing Tokugawa secrets to the enemy castle, and a plan was discovered that had been instigated by Hideyori through which Oribe's chief retainer, Kimura Munetaka, which called for setting fire to Nijō Castle and turn against the Tokugawa after Ieyasu and his son Hidetada had left Kyoto for Osaka for the 1615 siege. This treachery inevitably implicated Oribe himself.

Caught in events he could not control, he is quoted as saying, "When such things come to pass, any words of innocence are wretched," and he carried out the expected *seppuku* (honorable suicide) at his home in Fushimi. His heir, Shigehiro, was also forced to kill himself, and the Furuta family was stripped of its lands and property. The Fushimi residence was given to the general Tōdō Takatora. Oribe was buried at Gyokurin-an at the Daitoku-ji temple, and a tomb and a wooden likeness of him are located at the Kosei-ji temple at Nishijin, Kyoto. His posthumous Buddhist name is Kaneura Soya.

In 1967, I paid a visit to Kōsei-ji to confer about borrowing the statue of Oribe for an exhibition. My antiquarian's curiosity took me to search for Oribe's grave in the quiet wooded cemetery. There in the twilight I was surprised to find a most ordinary, small monument, no larger than the many others that stood alongside it. All that set it apart was the base stone, added later, setting it slightly higher than the others. Even given the ill fortune into which the powerful of his time had pushed him at the end of his life, I found it hard to believe that this was the tomb of one of the tea ceremony's greatest tea masters.

Sen no Rikyū, who was Oribe's tea ceremony teacher, was also forced to commit suicide, and one wonders if there was not some connection between the suicides of the two generations of tea men. Rikyū was sentenced on a spring day in 1591, and, fearful of the wrath of Hideyoshi, few friends save for Oribe and another famous tea master, Hosokawa Tadaoki, came to see the reclusive Rikyū off as far as the Yodo river crossing when he returned to his native Sakai to die. The previous year, from the encampment at Odawara during the offensive against the Hōjō, Rikyū had sent Oribe a letter—the now famous *Musashi Abumi no fumi*—that tells much of the friendship between the master and his disciple.

It is not completely clear when Oribe became involved in tea. Born in 1544, he was thirty-eight years old when his first liege lord, Nobunaga, was slain at Honnō-ji in 1582. Later in 1582, when Toyotomi Hideyoshi succeeded in unifying the country, Oribe was granted noble rank and became a provincial lord in Yamashiro. It was probably around this time that Oribe became known both as a distinguished general and a master of the tea ceremony. We know this from a letter written by Rikyū in the summer of 1582

Portrait sculpture of Furuta Oribe.

mentioning Oribe in an invitation to accompany him to visit the Myoki-an tea house in Yamazaki. A note in the February 13, 1585, entry of the *Tsuda Sōkyū chanoyu nikki*[1] that one Furuta Sasuke had held a morning tea party, is further evidence of his prominence.

During the Keichō period (1596–1615), the *Sōtan nikki*[2] notes tea functions held at Oribe's Fushimi residence and states that the current shogun, Tokugawa Hidetada, was sometimes a guest at Oribe's tea gatherings. In 1610, Oribe went to Edo to teach Hidetada tea ceremony, and he became Hidetada's much revered mentor.

Oribe was numbered among Rikyū's leading disciples, men prominent both in power and in artistic connoisseurship, who included the so-called Seven Great Disciples: Gamō Ujisato, Hosokawa Tadaoki, Seta Kamon, Shibayama Kenmotsu, Takayama Ukon, Makimura Hyōbu, and Oda Uraku. That the son of a local landowner could rise to become one of the greatest tea masters of the day graphically illustrates the kind of social mobility that prevailed in that turbulent period. Some records, such as the *Kōshin hikki*, the tea journal of Kōshinsai Sōsa, the third son of Sen Sōtan (1577–1658), who was the fourth-generation master of the Omotesenke tea school, count Oribe as one of Rikyū's Seven Great Disciples, but the times were not always in his favor, and there are many tea records that do not include him in that elite group.

Rikyū boldly taught his students that the way of tea should foster an open-minded and creative inventiveness. A man who had survived by the sword the endless intrigues and strife of the period, Oribe's tea, unlike the relatively static, reclusive tea of Rikyū, forcefully expressed his personal preferences. So-called Oribe taste was robust, rough, magnanimous, free in form, an aesthetic surprisingly distant from that of Rikyū, whose preferences were best typified by the balanced tranquillity and introverted character of the early Raku teabowls.

Rikyū was a man who could use a teabowl, like his much loved Raku "Kimamori" bowl made by Chōjirō, over thirty-five times before his death and still not tire of it. Oribe's favored teabowls were of a humorous, distorted character, like the "comically flawed Seto teabowl used to serve tea" men-

tioned in the *Sōtan nikki*. Later tea men must have thought it almost sacrilegious to include among Rikyū's most favored disciples a man like Oribe, whose taste was so contrary to Rikyū's own modest preferences. And yet, it was Rikyū who believed that originality is the antithesis of imitation of others, and Oribe's way of tea was precisely what he had intended to teach. Though later tea masters have scrupled to include Oribe in their histories of tea, he was plainly a most worthy representative of a time that looked out upon the dawn of the modern age.

MINO POTTERY

Mino pottery consists of Shino, Oribe, Yellow Seto, Seto Black, and Mino Iga ware, five types that were first made almost simultaneously. The process of glaze development was different for each of the five, but it is not possible to do more than touch on that topic and on other subjects such as the uses of vessels, structure of the kilns, and so on in this brief introduction.

Among the Mino glazes is Seto Black, a lustrous black iron glaze that recalls the teabowls of Chōjirō, the first generation of Raku potters. It is still not completely clear what the connection between Raku and Seto Black was or which glaze was first used. Quite apart from any possible connection, nevertheless, we may note that while Raku had its beginnings in roof-tile kilns and utilized low-fired, lead glazes, Seto Black can be traced to the ash and iron glazes of old Seto ware.

Shino ware is characterized by its snowlike thick white glaze. It is Japan's first white-glazed ware, and, its very whiteness an invitation to decoration, it is Japan's oldest pottery with colored decorations. Unlike Oribe, Shino was fired in the pit kiln *(anagama)*, which made possible the rich texture of its glaze. The earlier pieces are covered with feldspathic glaze low in natural silicon, which gives them a fleshy, nontransparent surface texture. The later the piece, the greater the proportion of silicon in the glaze and the more transparent the texture. Because of this effect, later Shino pieces begin to resemble decorated Oribe.

Yellow Seto, as the name implies, is a yellow ware whose basic color is provided by wood ash glaze. It again evokes the connection with Old Seto *(ko-Seto)* ware, which was fired in nearby Seto in former times. We can easily imagine that Old Seto ware exerted influence over the production of Yellow Seto in the Mino area. It can be argued that Yellow Seto ware has its origins in Old Seto pottery made for daily use, and that Yellow Seto as a ceramic art was first simply yellow Seto pottery in the broad sense; this later became the mainstream of so-called Yellow Seto.

Indeed, excavated examples of Yellow Seto go back to very early times. Yellow Seto has been found, for example, in the remains of Ōmori Castle built in Kanimachi, Mino, in the Eiroku period (1558–70). The castle of a provincial lord named Okumura Matahachirō Motonobu during the early Tenshō period (1573–92), it fell in 1583 to another provincial lord, Mori Chōka, and Okumura fled to the province of Kaga, where he became the guest of the powerful Maeda family. Along with the parched grains of rice used for soldier's provisions in the ruins of this castle was found a small Yellow Seto dish with impressed flower design as well as a *tenmoku* teabowl. Examples of Yellow Seto have been found in such castle sites not only in Mino, where they were made, but all over the country, indicating that Yellow Seto became one of the standard wares produced in this part of the country from the medieval period.

The history of Mino ware can be read in excavation sites other than those of the old kilns. For example, Oribe fired at the Yashichida kiln was found along with wooden bowls in the well of the residence of a man named Senmura, the head of a warrior band called the Kisoshū. An unusually remote site is that in Shinobu-chō, Iga-Ueno, where Black Oribe and a beautiful Yellow Seto shard with green copper glaze were unearthed. A Decorated Karatsu *mukōzuke* food dish (perhaps from the Kameya valley kiln) was simultaneously discovered.

More than ten years ago, when the Nihonbashi Post Office in Tokyo was rebuilt in its location behind the Takashimaya Department Store, several old Mino pieces were found. The chief of the construction work gave them to me. They included a small Yellow Seto dish, a Monochrome Oribe *mukōzuke* food

dish decorated with a man on horseback and green Oribe glaze on the rim, and a small dish with a chrysanthemum design in iron glaze on the inside.

THE VARIETIES AND TECHNIQUES OF ORIBE

Green Oribe (ao-Oribe)

Green Oribe denotes ware that is partially covered with green copper glaze, the rest decorated with designs in iron glaze. One of the greatest attractions of Oribe ware in general is the beauty of this green glaze, and pieces of this variety are the most numerous.

The green copper glaze is made by blending a copper salt with feldspathic and wood ash glaze. The texture and depth of the green depends on the quality of the basic glaze. The older the piece, the simpler the method of mixing the glaze. Particularly important is the selection of the feldspathic glaze, and careful attention must be given to the quality of the oak ash, which is an important element of Shino and other glazes as well. The softer and more transparent the glaze, the richer and more vivid the green appears. The glaze is not applied with a brush, but by dipping or trailing or ladling on the piece; simple methods but, as the old pieces show, the most effective.

Oribe shards, excavated at Nihonbashi, Tokyo.

The dark line decorations accompanying the green glaze are done in iron made from brown iron ore, and again, there is considerable variation in this iron color, depending on the quality of the ore from which the glaze is made as well as the manner of firing. The transparent glaze over which the iron decorations are applied is a blend of a small amount of wood ash glaze with feldspar.

Since green copper glaze turns red in reduction firing, Oribe is always fired in an oxidizing atmosphere. However, if the kiln atmosphere is completely oxidizing from the start, the green may be beautiful but thin (this can be given as the explanation for the dullness of many modern wares made with this glaze). For this reason, the imperfectly built kilns of ancient times, fired under completely natural conditions, were capable of creating magnificent pottery not reproducible by chemical science.

Monochrome Oribe (sō-Oribe)
This variety of Oribe is completely covered (except for the foot) with the copper green glaze and may be completely unadorned, have openwork patterns, or incised patterns underneath the glaze. The majority of incised designs are line drawings such as iris or men on horseback.

Narumi Oribe
This type uses both red and white clay together on the same piece; green glaze is applied over the white clay portion, and line decorations are painted in iron over a coat of white slip on the red clay. The subtle harmony of red, green, white, and black makes Narumi Oribe the most colorful of this kind of pottery. Some pieces are made with molds, including serving dishes, square dishes, and *mukōzuke* food dishes, and some are thrown on the wheel, such as teabowls and cylindrical *mukōzuke*. The latter include pieces with white clay sprigged on around the rim only, that is, where the green glaze is applied. In making molded pieces, such as flat *mukōzuke* or square dishes, the red and white clay is either placed on opposite sides of the mold or pressed together when the clay is put into the mold. It is a complicated procedure, but makes a decisive difference in the final effect, since the color of the green glaze is

much more vivid when applied over white clay. All ceramics shrink approximately 20 percent in firing, and if the shrinkage rate for the two types of clay is different, the piece will come apart, so the technique requires thorough familiarity with the nature of the clay. Molded pieces often have the mark of fabric faintly impressed on the surface. This is the trace left by a layer of cloth placed between the mold and the clay to facilitate removal.

Until not long ago, I was once told, Narumi Oribe was believed to have gained its name because pieces of this type were made in the Narumi area of the present-day city of Nagoya. This idea may have arisen because of a presumed likeness to the bold resist-dyed cotton textiles of the area known as *Narumi shibori*. This dyeing, which developed under the protection of the Tokugawa lords of Owari during the Edo period, included many different types. There are many examples of Oribe ware, as in many other types of Japanese pottery, that show the use of textile patterns, including classical Chinese-style motifs. The influence of design between the worlds of textiles and pottery could have been mutual or could well have been only a one-way borrowing.

Handled dish. Tokyo National Museum.

Red Oribe (aka-Oribe)
Red Oribe consists of pieces made with the techniques used in the red clay portions of Narumi ware, that is, pieces of red clay painted with white slip and decorated with line patterns in iron. This type of Oribe includes low *mukōzuke,* dishes, plates, small bowls, incense boxes, teabowls *(mukōzuke* adapted to use as teabowls); wheel-thrown *mukōzuke* are especially common.

Oribe Black (Oribe-guro)
Vessels glazed completely with black are known as *Oribe-guro.* Like Black Seto, they are taken from the kiln and cooled rapidly to bring up the luster of the black glaze; if left in the kiln to cool gradually, the black glaze grows somewhat brownish. This is a type common among teabowls, all of which are either of the "shoe" shape or cylindrical with some degree of distortion.

Black Oribe (kuro-Oribe)
The same glaze as for Oribe Black ware is used, but on only part of the piece. White glaze may be applied afterwards over the remaining portion of the vessel. Some are decorated further with iron on the white portion, or the decoration may be the white portion itself, surrounded by black glaze.

Shino Oribe (also called Plain Oribe)
This term identifies white Oribe that looks at first glance somewhat like Shino but is made in a chambered climbing kiln and has much more thinly applied feldspathic glaze of a lustrous quality resulting from increased amounts of silicon. Compared with Shino, it is a thin-walled, hard-fired ware and lacks the red tinge of the former.

Decorated Oribe (e-Oribe)
Shino Oribe with iron decoration is known as *e-Oribe,* or, as the late Tōkurō Katō called it, *"Oribe sometsuke"* ("printed" Oribe). Ash is added to the feldspar, and the ash glaze has an increased transparency that comes close to glass, which indeed gives the iron decorations the effect of having been printed on.

Mino Iga

The characteristic qualities of Iga ware are scorching *(koge)*, glaze drips, and reddish tints. Especially beautiful is the effect created by cascading drips of natural glaze. Mino Iga imitates true Iga ware in shape and is covered with a thin overglaze. Iron glaze is dripped down the side of the pieces, taking the place of natural ash glaze runs. By far the majority of Mino Iga pieces are water containers for the tea ceremony, vases, and, rarely, teabowls. The shapes as well as types of vessels are usually patterned after early, prototypic Iga pieces.

TYPES OF VESSELS

Teabowls (chawan)
There are basically two varieties of Oribe teabowls, "shoe-shaped" or so-called *Oribe-gonomi* bowls and those originally made as *mukōzuke* dishes and later used as teabowls.

Dishes (hachi)
Serving dishes come in all sizes and numerous shapes: square, with indented corners, four-petaled, circular, "kimono-sleeve" shaped,[3] fan-shaped, etc. Some have openwork on the sides, are shaped like a *shamisen* plectrum are fitted with flaired feet, or are platterlike or bun-shaped. Dishes with handles, called *tebachi,* may be circular, square, or fan-shaped.

Lidded dishes (futamono)
Here, too, there are many common shapes: square, rectangular, indented corners, and fan-shaped, some with feet, some flat-bottomed. The lid handles are modeled in a variety of abstract or realistic shapes.

Mukōzuke
These dishes for serving food in the *kaiseki* meal accompanying the tea ceremony are made in two basic types: deep (including *"nozoki"* or openwork

pieces) and flat. Deep *mukōzuke* may be square, circular, fan-shaped, indented, and bulging, irregular shapes. Shallow *mukōzuke* come in countless stylized and many realistic shapes, including plectrum-shaped, fan-shaped, crescent-shaped, boat-shaped, flower-shaped, etc.

Incense boxes (kōgō)
Incense boxes, too, display numerous shapes patterned after such things as chrysanthemums, a warrior's helmet, fan, circle, square, and hats worn by court nobles in ancient times. The knob or handle on the lid is often cleverly modeled in the form of a fish, flower, bamboo branch, or simply an arc or loop.

Incense burners (kōro)
Incense burners have a great range of shapes, from realistic forms such as lions or owls to forms emulating certain Chinese celadon porcelains.

Water containers (mizusashi)
Water containers for the tea ceremony seldom display green Oribe glaze, but in most cases are of the Mino Iga type, whose shapes are reflections of Iga ware models.

Vases (hanaike)
Oribe ware includes very few vases, the best known being the square example shown in Plate 35.

Tea caddies (cha-ire)
The majority of Oribe tea caddies were made expressly for that purpose, either covered completely with iron glaze or with designs in white glaze added over the iron glaze. There are a very few tea caddies of bucket shape or cylindrical shape adapted from what were originally deep *mukōzuke*.

Saké drinking vessels (shuki)
Saké bottles are typically slender necked and tall bodied. Saké cups may be

Monochrome Oribe pieces with flaired lip or hexagonal shape or hexagonal iron-glazed pieces. Originally these were made as *choku,* a type of small *mukōzuke.*

Saké bottles (chōshi)
Ranging from large to small, these bottles are of various kinds, some with lids or handles, tall and slender or low in construction.

Shaker or sprinkling bottles (furidashi)
These slender-necked, diminutive vessels include some green-glazed and some iron-glazed pieces.

Furidashi *(sprinkling bottles).*

Miscellaneous
There are, in addition, Oribe pieces that are not for eating or drinking, including utensils for writing (inkstones and fish- or animal-shaped water droppers), pipes, lamps, saké cup stands, cup-shaped *mukōzuke,* folding screen stands, and even pulley wheels for ropes holding well buckets.

THE ORIBE KILNS

Motoyashiki (Kujiri)
This is the oldest kiln where Oribe ware was fired. The full range of vessels and styles was made here, and the overwhelming majority of important and famous works come from this kiln. Most of the Mino Iga pieces were made at Motoyashiki as well as imitation *tenmoku,* Yellow Seto, Shino, Seto Black, and even imitation Karatsu.

Motoyashiki kiln site at Kujiri.

Shōbu (Kujiri)

Second only to Motoyashiki in the number of excellent pots made there, Shōbu (also called the Inkyo kiln) produced works of a slightly more refined quality. It is the birthplace of some excellent examples of Narumi and Red Oribe.

Kamane (Kujiri)

Along with Motoyashiki and Shōbu, Kamane is one of the leading kilns in Kujiri and one known especially for the production of Monochrome Oribe. Small dishes decorated with simple incised iris designs, grasses, or hatted men on horseback and dipped in green glaze are typical products of this kiln.

Yashichida (Ōgaya)

Located in Ōgaya, rather remote from the other Oribe kilns, Yashichida was near kilns that made Shino ware; the Yashichida ware is the most elegant and refined in proportion and design of all the Oribe styles. Light and fine of body, the vessels fired here are decorated with fine lines in iron, an intermediate color with white slip mixed in, and scant trails of blue-green glaze. The pottery of this kiln tends to be slightly underfired compared to other types of pottery, and this is perhaps because the clay could not withstand high temperatures.

So delicate is the quality of these pieces that some have speculated that the great Kyoto potter Nonomura Ninsei was in some way connected with the Yashichida kiln. However, it produced pottery in the "Oribe taste" in the broad sense only from Momoyama to the early Edo period, so it seems more likely that it was the reverse, that Yashichida influenced the Kyoto kilns, including that of Ninsei.

Seidayū (Ōhira)

The products of this kiln are rather inferior in workmanship to those of the Kujiri kilns. The clay tends to be somewhat softer than that of Kujiri, however, which might have made fine techniques actually easier to achieve.

Square plates, handled dishes, and ewers are among the pieces most commonly made at this kiln.

Ōtomi
This kiln is believed to be the last to fire Oribe wares between the Momoyama and early Edo periods. Greater emphasis was given to miscellaneous utensils for popular use than to tea wares, and it is reasonable to think that this approach led the way in the general production of items for everyday use at the Mino kilns in the middle and latter part of the Edo period. The green copper glaze of pieces from this kiln is especially vivid, and there are some notable pots among its production.

MUTUAL INFLUENCE BETWEEN ORIBE AND KARATSU

Oribe and Karatsu pottery share similarities of both decoration and shape. For example, the lotus leaf-shaped *mukōzuke* dish is common to both types, as are such motifs as drying fish nets and plovers. In fact, in 1592 Furuta Oribe did go to visit the headquarters of the forces at Nagoya in Hizen (Kyushu) as a member of the rear guard in Hideyoshi's invasion of Korea, so it is possible that he made some contact with the Karatsu kilns at that time. Even aside from any efforts of Oribe himself, a look at the *mukōzuke* of the Koyamaji kiln at Karatsu would seem to be convincing evidence for a clear connection with Mino pottery.

Among the documents of Mino is one entitled *Seto ōkama yakimono narabi ni Karatsu kama toritate no raiyusho* ("An Account of the Pottery of the Great Kilns of Seto and the Introduction of the Karatsu Kiln"). The first half of the account records that the Nara period priest Gyōki Bosatsu (668–749) had first fired jars in a pottery village in Izumi Province (present-day Osaka) and includes the following passage:

> In Owari in the village of Seto there was a man named Katō Shirōemon who made tea caddies. Shirōemon's son came to this

area [the postscript notes that it is a pottery village called Kujiri in Toki County in the province of Mino] and made pottery for several years.... and then he was made a magistrate [in Mino]. A lordless samurai named Mori Zen'emon who happened to be from Karatsu in Hizen came to Mino and, seeing the kiln of the magistrate, remarked, "What a shame, the fire is going to waste!" The magistrate then asked how kilns were built in Karatsu. When Zen'emon returned to Hizen, he took with him a manservant who learned how to build a kiln in the Karatsu manner. When he went back to Mino, the magistrate promptly had him build a kiln on the grounds of his estate and erected a high wall around it in the attempt to keep the secret of his new kiln from others. No matter how earnestly the potters of other kilns nearby begged to see it, he would not show them. So these men got together and decided to wait until the New Year would allow them an occasion to visit the magistrate's residence to pay their annual respects. Then one of them should stealthily contrive to get a look at the kiln. When the New Year came, a great banquet was held at the magistrate's residence, during which a young man named Ninhei, one of the sons of Matsubara Tarozō, left the hall on pretext of relieving himself and went out the gate and climbed into the high-walled enclosure. As he was carefully examining the kiln, he was discovered by a watchman, who shouted for help to catch the trespasser. In the ensuing furor, Ninhei's companions managed to flee, and he, too, was finally able to make his escape.

The ruins of this kiln in Mino remain today—the Motoyashiki kiln. The account has not been entirely authenticated, but it is interesting that even in those times, a potter might risk his neck for the sake of gaining techniques, which would increase his profits.

ORIBE'S INTEREST IN WESTERN THINGS

Some have speculated that Furuta Oribe was a Christian. He was related by blood to the great Christian daimyo Takayama Ukon, and there are, indeed, Oribe teabowls with the letters IRS (from Greek letters meaning Jesus) or with the cross inscribed on them. Also, on the front of the lower portion of a stone garden lantern known as the Oribe lantern there is a relief of a figure in a cloak believed to be a Christian or missionary. A document written by one Wataya Uhei in 1644 records that a lantern donated to the Tōgara Tenjin Shrine on Ōusumura in the western quarter of Kyoto was called the "Furuta Oribe Favorite Stone Lantern." However, as observed before, Oribe took his own life by ritual suicide, so there is still no convincing evidence that he was, in fact, Christian.

CONCLUSION

From the Momoyama through the early Edo period, Oribe ware rapidly developed in the great flowering of the ceramic arts at the time. Then the world of pottery began to shift toward the production of ceramics for popular, everyday use, as typified by kilns such as Kasahara, and production of Oribe never again returned to its former glory. Late in the Edo period there was a revival of Oribe in the Seto area. Many fine pieces were produced by famous potters, including Shun'ei, Shuntan, Shuntai, Kurō, Shungyo, and Shunkozan, but I believe these belong to a separate category of inquiry.

In writing this manuscript, I would like to acknowledge with fond remembrance the opportunity to enjoy the "Seminars on Ceramics and Exhibition of Oribe Ware" and in 1967 the "Exhibition of Great Works of Oribe" sponsored by the Japan Ceramics Association, where I am now employed. I am indebted to the valuable catalog and commentary the late Hajime Katō prepared for that showing. I am also grateful to Tadachika Kuwata for use of parts of his survey of Furuta Oribe's life prepared for that exhibit.

TEXT NOTES

1. *Tsuda Sōkyū chanoyu nikki* ("The Tea Diary of Tsuda Sōkyū"), also called the *Tennōjiya kaiki* ("Tennōjiya Tea Journal"). A record of the tea ceremonies held both by the Tennōjiya family (of Sakai, Osaka) and elsewhere, it extends over three generations from 1548 to the end of the Tenshō era (1592), recording some 2,560 tea ceremonies during the three generations.

2. Also known as the *Kamiya Sōtan nikki*. One of the three most famous tea diaries, it extends from the Tenshō era (1573-92) to 1644.

3. *irizumi* *mokko* *tagasode*

SHINO

1. Picture Shino water container, name: *Kogan* ("Weathered Shore"). H. 18.0 cm. Important Cultural Object. Hatakeyama Collection.

2, 3. Picture Shino teabowl. name: *U no Hanagaki* ("Fence of Deutzia Flowers").
D. 11.8 cm. National Treasure.

4, 5. White *Tenmoku* teabowl.
D. 12.3 cm. Important Cultural Object. Tokugawa Reimeikai Foundation.

6

7

8

6. Gray Shino, "'picture frame" shallow dish, design of grasses and flowers.
W 23.7 cm. Umezawa Memorial Gallery.
7. Gray Shino sewing dish, design of grasses.
W. 16.0 cm. Hakone Museum of Art.
8. Picture Shino bowl, design of flowering plum branches.
W. 26.9 cm. Hakone Museum of Art.
9. Plain Shino saké bottle; Shino Oribe saké bottle.
Left: H. 17.5 cm. Right: H. 18.0 cm.

10

11

12

10. Gray Shino teabowl, name: Yama no Ha ("Mountain Ridge"). D. 13.3 cm. Nezu Art Museum.
11. 12. Picture Shino teabowl. D. 13.5 cm.

13. Shino serving dish,
 repaired. H. 6.8 cm.
14, 15. Gray Shino teabowl,
name: *Mine no Momiji*
("Summit Maple Leaves").
D. 13.6 cm.
Gotō Art Museum.

16. Picture Shino teabowl. D. 11.8 cm.
17. Picture Shino teabowl. D. 18.0 cm.
18. Shino teabowl, name: *Hagoromo* ("Feather Cloak"). D. 13.4 cm.

19. Picture Shino teabowl. D. 13.4 cm.
20. Shino *tenmoku* teabowl. D. 12.0 cm.
21. Picture Shino teabowl, name: *Matsushima* ("Pine Islands"). D. 13.0 cm.

22. Picture Shino, small serving dishes (mukōzuke), four-sided with pinched-in corners. H. 6.8 cm.
23. Picture Shino bowl, design of flying birds. D. 16.8 cm.
24. Picture Shino serving dish, design of iris. D. 19.0 cm.

25

26

28

25. Deep serving bowl,
protruding decorations. H. 8.1 cm.
26. Picture Shino, cylindrical sewing dish,
design of willow and bush clover.
H. 9.7 cm.
27. Picture Shino serving dish,
design of pampas grass. D. 16.8 cm.
28. Gray Shino serving dish,
design of grasses and flowers. D. 17.2 cm.

27

29. Picture Shino serving dish, design of autumn grasses. W. 15.8 cm. H. 4.7 cm.
30. Picture Shino serving dish. W. 15.8 cm. H. 5.5 cm.
31. Picture Shino serving dish. W. 15.4 cm. H. 6.3 cm.
32. Gray Shino serving dish, design of grasses. W. 16.0 cm. H. 6.0 cm.

33. Gray Shino bowl, design of grasses. W. 15.9 cm. H. 3.6 cm.
34. Picture Shino bowl, protruding decorations. D. 23.8 cm. H. 8.0 cm.
35. Picture Shino serving dish, design of heron. W. 16.4 cm.
36. Picture Shino small four-sided bowl. D. 15.4 cm. H. 6.0 cm.

37

38

39

40

41

42

43

66

44

45 *46*

37. Shino Oribe saké server. H. 18.0 cm.
38. Plain Shino fish-shaped water dropper; Green Oribe fish-shaped water dropper. L. 10.6 cm.
39. Gray Shino catfish-shaped incense box, designed by Seison Maeda. L. 6.2 cm.
40. Picture Shino ember holder, design of shellfish. H. 8.5 cm.
41. Picture Shino incense box. D. 6.0 cm.
42. Plain Shino incense box, by Toyozō Arakawa. H. 3.2 cm.
43. Picture Shino incense box. H. 4.5 cm.
44. Picture Shino "picture frame" bowl, design of grasses and flowers. W. 13.0 cm. H. 5.0 cm.
45. Picture Shino deep bowl, design of grasses and flowers. H. 18.0 cm.
46. Picture Shino "picture frame" bowl, design of Chinese buildings and human figures. W. 15.2 cm. H. 3.9 cm.

47. Shino Oribe saké pot.
H. 16.8 cm.
48. Picture Shino shallow bowl. W. 24.8 cm.
H. 5.0 cm.
49. Gray Shino bowl, bracken fern design.
D. 26.2 cm. H. 5.7 cm.

50. Plain Shino saké cups. D. 7.1 cm. H. 4.0 cm.
51. Plain Shino sake' cups. Left: D. 6.5 cm. Middle: D. 6.8 cm. Right: D. 5.9 cm.
52. Picture Shino deep, square serving dish *(mukōzuke)*. H. 7.0 cm.
53. Picture Shino "picture frame" bowl, design of wild grapes. W. 24.0 cm. H. 5.1 cm.

CONTEMPORARY SHINO WARE

54. Picture Shino teabowl, by Shintō Katō. D. 12.9 cm.
55. Red Shino teabowl, by Seizō Katō. D. 13.1 cm.
56. Picture Shino teabowl, by Osamu Suzuki. D. 13.4 cm.
57. Plain Shino teabowl, by Seisei Suzuki. D. 13.0 cm.
58. Picture Shino teabowl, by Hidetake Andō. D. 13.1 cm.
59. Picture Shino teabowl, by Kōzō Katō. D. 12.6 cm.
60. Plain Shino teabowl, by Yasuo Tamaoki. D. 13.2 cm.
61. Gray Shino teabowl, design of flying cranes, by Toyozō Arakawa. D. 12.8 cm.
62. Picture Shino teabowl, by Tōkurō Katō. D. 14.2 cm.
63. Gray Shino teabowl, by Rosanjin Kitaōji D. 10.8 cm.

61

62

63

64

65

66

67

68

69

64. Picture Shino teabowl, design of Chinese bellflowers, by Naoki Nakayama. D. 12.7 cm.
65. Gray Shino teabowl, by Takuo Katō. D. 12.8 cm.
66. Picture Shino teabowl, by Kōtarō Hayashi. D. 13.1 cm.
67. Plain Shino teabowl, by Kenji Kishimoto. D. 12.5 cm.
68. Gray Shino teabowl, by Toshisada Wakao. D. 13.7 cm.
69. Plain Shino teabowl, by Shuntei Katō. D. 12.0 cm.

ORIBE

1-3. Black Oribe teabowl, lily design. D. 15.1 cm. Umezawa Memorial Gallery.

4

5 6

7

74

4, 5. Black Oribe teabowl, belfry design (name: "Dōjōji"). D. 13.8 cm.
6, 7. Narumi Oribe teabowl. D. 14.7 cm.
8–10. Black Oribe teabowl, Mt. Fuji design. D. 14.6 cm.
Tokyo National Museum.

11. Black Oribe teabowl, *dango* design.
D. 12.3 cm. Nezu Art Museum.
12. Black Oribe teabowl,
geometric design (name: "Shimo-gare").
D. 14.3 cm.
13. Plain Black Oribe teabowl
(name: "Unrin"). D. 14.5 cm.
14. Decorated Oribe pedestaled
teabowl *(bajōhai* type). D. 12.8 cm.

15

16

15. Handled dish. D. 23.8 cm. Idemitsu Museum of Arts.
16. Fan-shaped handled dish. L. 29.3 cm.

15

16

17. Square dish, tortoiseshell pattern. L. 23.8 cm.
18. Square dish, floral scroll pattern. L. 21.5 cm.

15

16

19. Square dish, stripe pattern. L. 22.7 cm. Nezu Art Museum.
20. Rectangular lidded dish. L. 23.0 cm.

21. Fan-shaped lidded dish. L. 29.8 cm.
22. Fan-shaped lidded dish. L. 28.4 cm.
Umezawa Memorial Gallery.
23. Square lidded dish. L. 21.2 cm.
24. Square indented *mukōzuke* food dishes.
L. 12.4 cm.
25. Plover *mukōzuke* food dishes. L. 13.8 cm.

24

25

26. Rhomboid *mukōzuke* food dishes. L. 20.3 cm.
27. Crescent-shaped *mukōzuke* food dishes. L. 15.8 cm.
28. Handled *mukōzuke* food dishes. Hatakeyama Collection.
29. Openwork *mukōzuke* food dishes. H. 113 cm. Umezawa Memorial Gallery.
30. Boat-shaped *mukōzuke* food dishes. L. 20.8 cm.

24

24

25

31

32

33

34

31. Tea caddy. H. 11.2 cm.
32. Eared Mino Iga water container. H. 18.6 cm.
33. Bucket-shaped tea caddy. H. 10.6 cm. Nezu Art Museum.
34. Eared Mino Iga water container. H. 20.3 cm.
35. Vase, stripe pattern. H. 30.2 cm. Umezawa Memorial Gallery.
36. Incense burner with handles. H. 8.8 cm.
37. Incense box, scroll pattern. H. 4.1 cm. Idemitsu Museum of Arts.
38. Square incense box, human and bird figures. H. 4.3 cm.
39. Pinnacled incense box (name: "Shigure"). H. 5.4 cm. Idemitsu Museum of Arts.
40. Incense box, eggplant shape. H. 7.2 cm.

35

36

37

38

39

40

85

41

42

43

44

41. Bottle, diadem and grapevine design. H. 24.9 cm.
42. Monochrome Oribe saké cups. D. 6.0 cm.
43. Ewer with handle. H. 30.9 cm. Nezu Art Museum.
44. Saké flask, spatterdock design. H. 19.5 cm.

45, 46. Pipes. Plate 45, L. 12.5–13.4 cm.; Plate 46, L. 7.6–9.6 cm.
47. Candleholder figurine. H. 23.4 cm. Umezawa Memorial Gallery.
48. Monochrome Oribe inkstone, water-flower design. L. 16.8 cm. Umezawa Memorial Gallery.
49. Monochrome Oribe inkstone, squash-flower design. L. 17.0 cm. Tokyo National Museum.
50. Fish-shaped waterdroppers. Large, 11.1 cm.; small, 9.0 cm.
51. Monochrome Oribe flower-stamped waterdropper. H. 2.8 cm.

48

50

49

51

52

53

54

55

56

57

58

59

52. Monochrome Oribe plate.
D. 49.1 cm. Hidetake Andō.
53. Monochrome Oribe dish, iris design.
D. 29.7 cm. Seizō Katō.
54. Monochrome Oribe plate.
L. 32.3 cm. Yasuo Tamaoki.
55. Narumi Oribe plate. L. 40.7 cm.
Toshisada Wakao.
56. Handled dish. D. 23.8 cm. Kiheiji Takiguchi.
57. Monochrome Oribe plate.
L. 40.2 cm. Osamu Suzuki.
58. Black Oribe teabowl. D. 14.6 cm.
Mitsuemon Katō.
59. Narumi Oribe *mukōzuke* food dishes.
W. 16.2 cm. Kōtarō Hayashi.
60. Oak leaf-shaped dishes. L. 23.8 cm.
Rosanjin Kitaōji.
61. Handled dish. L. 28.5 cm. Tōkurō Katō.
62. Handled dish. H. 16.4 cm. Takuo Katō.
63. Narumi Oribe teabowl. D. 13.0 cm.
Tadashi Sasaki.
64. Monochrome Oribe flower vase.
H. 26.3 cm. Shuntei Katō.

ORIBE POTTERY DESIGNS

65. water lily

66. spatterdock

67. pine

68. flowering plum

69. cherry blossoms

70. feather fan

71. plum tree and bush warbler

72. deer

73. rabbit

74. deer

75. characters

76. characters

77. dot pattern

78. arrows

79. geometric design

80. dangling clappers

81. patterns

PLATE NOTES

SHINO

In a good piece of Shino, brown tinged with a pleasing red suffuses the white ground. To see this is to know joy.

—Kitaōji Rosanjin

1. Picture Shino water container, name: Kogan *("Weathered Shore"). H. 18.0 cm. Important Cultural Object. Hatakeyama Collection.*

There are not many Old Shino water containers to be found in Japan. The most famous of this elite group is the piece known as *Kogan*. It was probably fired at the Ōgaya Kamashita kiln at the beginning of the seventeenth century.

Its bottom edge *(tatamitsuki)* is extremely powerful. The lip has been notched, and the neck squeezed in with mathematical, almost frightening, precision. One might mistakenly assume that Furuta Oribe had a hand in this piece, as it is very much in the style he espoused. There is nothing incomplete about it.

The continuous design on the pot is not itself unusual, but here the execution is grand. It is hard to believe that it was done by a potter. Kitaōji Rosanjin has said that it is not necessary to stare long and hard at the pictures drawn by Momoyama potters. This jar is a wonderful example of that principle.

The color of the feldspathic Shino glaze is especially fine. The design—it is difficult to tell whether it is of reeds or pampas grass—is lively.

It seems to have been thrown rather casually, omitting fine details. It owes much of its effect to the events that occurred during firing: *ishihaze* ("stone bursting"—pits caused by the melting of feldspar granules in the clay) and cracks by the heat.

It is not known who named the pot *Kogan*, but one can imagine that the lonely name was inspired by a cold, late autumn wind blowing off the mountains.

2, 3. Picture Shino teabowl, name: U no Hanagaki *("Fence of Deutzia Flowers"). D. 11.8 cm. National Treasure.*

This bowl is said to have originally been in the possession of the Fuyuki family, apparently one of Tokyo's most prosperous houses in the Edo period. From Tokyo, the bowl came into the hands of the Yamada Hachirōbei family of Osaka. Subsequently, according to the *Taishō meikikan*, it was sold at a Kyoto auction in 1890 for the sum of 1,000 yen in gold. Now it belongs to the Mitsui family.

Given the fact that there are virtually no other teabowls in Japan that have been designated National Treasures, it seems safe to say that this is the finest teabowl in existence.

The inscription on the box lid is attributed to the tea master Katagiri Sekishū. On the inside of the lid a poem card has been affixed with a poem that reads:

The inner essence
Of the fence of deutzia flowers
In a mountain village:
The feeling of treading a road
Covered with freshly fallen snow.

It is not certain who wrote this poem, but the style of calligraphy is one at which Sekishū excelled, so some think that this poem is his as well.

The bowl was fired at the Ōgaya Mutabora kiln. Its irregular shape is indescribably elegant. The glazing, too, is superb. The red at the lip, caused by the fire in the kiln, and the flowing design, are especially beautiful.

There is another teabowl, called *U no Hana* ("Deutzia Flowers"), done in the same style. The late Fujio Koyama reported in a journal article that a third companion piece, a bowl with pine tree design, turned up in Kanazawa.

It has been established that Katō Genjūrō Kagenari was the founder of the kilns at Ōgaya. And while the claim made by some that this bowl is one of his works may well be true, it seems strange that this should be the only known example of his pottery. A brown-glazed tea caddy attributed to him has been passed down through generations of the Konoe family, but only the Konoe family regards this as authentic. Genjūrō may in fact have made this tea caddy and the *U no Hanagaki* teabowl, but these attributions are traditional and cannot be proven.

4, 5. *White* tenmoku *tea bowl. D. 12.3 cm. Important Cultural Object. Tokugawa Reimeikai Foundation.*

This is a dignified white *tenmoku* teabowl lined with gold at the rim. (The *tenmoku* term comes from the utensils used at a Buddhist temple on Mt. Tenmoku—Tianmu in Chinese—in China's Zhejiang Province.)

Judging from the way the foot was trimmed, the bowl is thought to have been made sometime in the Tenshō era (1573–92), which means that it is one of the earliest examples of Shino's feldspathic glaze.

There are only two such bowls known to exist. One has been passed down through the Maeda family of Kaga. The bowl shown here has come down through the Owari branch of the Tokugawa family.

I saw this bowl well over ten years ago, but the memory of it is still with me. It is well rounded, not at all severe like Chinese *tenmoku*. It is soft, luscious, truly representative of Japanese *tenmoku*.

There is no question that Shino ware was made at Mino during the Momoyama and early Edo periods. There is a school of thought that holds that Shino's antecedents are in the Muromachi period, and its adherents maintain that this bowl was made in Owari at that time. But the more common view is, as stated earlier, that this bowl was made in the Tenshō era, probably at Ōhira. The so-called Chrysanthemum *Tenmoku* made at Seto (Owari) adheres strictly to the style of its Chinese predecessors made at the kilns of Jian. The walls of this piece, however, have been pulled up toward the top of the body to make it more bowlike. And the trimming of the foot is different from that seen in Chrysanthemum *Tenmoku*.

It is not known when the practice of offering a bowl of tea to the Buddha image in temples began, but we do know that in the Muromachi period bowls began to be made in Japan for that purpose to supplement bowls imported from China. I have one such Japanese bowl in my collection, though it is a black-glazed piece rather than Shino ware. Also, a yellow-glazed bowl unearthed at Akatsu and thought to be from the Northern and Southern Courts period (1336–92) shows a trimmed foot similar to the one on this White *Tenmoku* piece.

6. *Gray Shino, "picture frame" shallow dish, design of grasses and flowers. W. 23.7 cm. Umezawa Memorial Gallery.*

There are perhaps ten shallow dishes in existence

with "picture frame" shapes, but this piece is unique in terms of its decoration and its glaze application. The scenery deep in the mountains of Mino is depicted. The design and coloring combine to full and graceful effect.

Shallow dishes like this were produced at Ōhira, Ōgaya, and Kujiri. Each one has its own personality.

7. *Gray Shino sewing dish, design of grasses. W. 16.0 cm. Hakone Museum of Art.*

Since all Momoyama period serving dishes made for use in the meal accompanying a formal tea ceremony are large, today they are often used as bowls.

This piece was originally one of a set of five, but the rest have since been sold to different owners. It is of the finest workmanship, and its gray is a perfect example of the flames of the kiln at work.

As a serving dish, it is a fine piece, but as a piece of artistic pottery, it is even more noteworthy.

8. *Picture Shino bowl, design of flowering plum branches. W. 26.9 cm. Hakone Museum of Art.*

Tenkō, the god of the kiln, clearly had a hand in this piece. Among works of similar type, this bowl is preeminent. Its color is particularly clean, and it is considered the best example of a Shino serving bowl. Though some feel it is from Ōgaya, more likely it is a product of the Kujiri Motoyashiki kiln at its peak at the beginning of the seventeenth century.

9. *Plain Shino saké bottle; Shino Oribe saké bottle Left: H. 17.5 cm. Right: H. 18.0 cm.*

These were excavated in the vicinity of the Ōtomi kiln. No such bottles have been handed down; all are excavated pieces. They seem to have been used as everyday ware rather than as tea ceremony pieces.

Both have been repaired at the neck, but this does not detract from their appearance.

Shino sake bottles are rare. The design on the right-hand bottle is rhythmical and has a forceful beauty.

10. *Gray Shino tea bowl, name:* Yama no Ha *("Mountain Ridge"). D. 13.3 cm. Nezu Art Museum.*

Yama no Ha and Mine no Momiji ("Summit Maple Leaves"—Plates 14, 15) are widely known and considered a pair of matchless masterpieces. This bowl's form is solid, immovable. While Mine no Momiji is graceful and feminine, this piece is definitely masculine. It is hard to say which is the finer of the two. Both are thought to be from the Kamashita kiln at Ōgaya.

11, 12. *Picture Shino teabowl. D. 13.5 cm.*

This bowl comes from the kilns at Ohira. The color is a somewhat clouded, milky white. The thick walls were pulled up slowly. It has a strength not found in older bowls.

13. *Shino sewing dish, repaired. H. 6.8 cm.*

This dish was unearthed at the Ōgaya Mutabora kiln. The repair seen here was done either with shards from a similar piece or with ones from a completely different pot. The color in this dish is clear and quite refined.

14, 15. *Gray Shino teabowl, name:* Mine no Momiji *("Summit Maple Leaves"). D. 13.6 cm. Gotō Art Museum.*

Mine no Momiji and Yama no Ha (Plate 10) are the finest examples of Gray Shino. This bowl is the Gotō Museum's prize piece. The execution is elegant and there is a bittersweet quality to the pot. The color at the hip is unique, and the incised tortoiseshell

(hexagonal) and fencelike patterns give an effect resembling inlay.

16. *Picture Shino teabowl. D. 11.8 cm.*

Though technically a teabowl, this piece was not really made for drinking *matcha* (the powdered green tea used in the tea ceremony). Rather, it seems to have been intended for daily use. Apparently, quite a few Picture Shino and Shino Oribe pieces like this one were made.

From the 1530s on, the kilns at Kujiri evidently turned out many saké bottles and other miscellaneous pots. And from the early Edo period, rounded bowl-shaped pieces like this one were turned out in large numbers.

17. *Picture Shino teabowl. D. 18.0 cm.*

This bowl seems to be half in the Rikyū style and half in the Oribe style. The low foot is in Rikyū's taste. The clay is very fine, and the firing has brought out a beautiful color along with other attractive kiln effects.

18. *Shino teabowl, name:* Hagoromo *("Feather Cloak"). D. 13.4 cm.*

This heroic piece is thought to be from the Ōgaya Mutabora kiln. The potter's hands have put the expansiveness, the grandeur of the Momoyama period itself into this pot. One dreams of pouring hot water into it with a bamboo dipper made by the great Momoyama master Gamō Ujisato. One dreams, too, of some divine intervention that might allow one to sip tea from this bowl, even though it might not be quite so fine as *U no Hanagaki*.

19. *Picture Shino teabowl. D. 13.4 cm.*

This appears to be an early work in the Oribe manner, though faint reverberations of Rikyū remain. It has no name, but it is well fired, and the color is beautiful. It is rather shallow, but the workmanship is strong. It looks like a piece that might have been made by a Setoguro potter under the direction of Katō Genjūrō Kagenari.

20. *Shino* tenmoku *teabowl. D. 12.0 cm.*

This is perhaps a pioneer piece in the use of white Shino glaze. This bowl was unearthed from the vicinity of the Ohira kilns. The trimming of the foot is different from that found in Chinese *tenmoku* bowls. The shape, too, is unique. Thus, it is an example of a purely Japanese *tenmoku* teabowl. The repair material is also Shino, probably from the beginning of the seventeenth century.

21. *Picture Shino teabowl, name:* Matsushima *("Pine Islands"). D. 13.0 cm.*

This masterpiece has a fine, assymetrical shape. There seems no mistaking that it was made at the Ōgaya Kamashita kiln. In contrast to the heroic taste of the Momoyama period, this bowl is refined and temperate. The walls lean slightly inward, the hip swells out quietly. The potter's artistry is locked deep inside the bowl. The name of the piece comes from the picture on the side, which depicts one of the famous pine-covered islands of Matsushima.

22. *Picture Shino, small serving dishes* (mukōzuke), *four-sided with pinched-in corners. H. 6.8 cm.*

These thin-walled and graceful dishes are highly prized as rare and elegant examples from the Ōgaya kilns. It is hard to tell whether the pictures are of Pine trees and a mountain peak or grasses growing at the base of the mountain, but such abbreviated

designs are common in early products from the Ōgaya potters. As small serving dishes for the tea ceremony meal, these are unsurpassed.

23. *Picture Shino bowl, design of flying birds. D. 16.8 cm.*
The rim is slightly inverted, and the bowl is supported by three feet. The piece was fired at Ohira sometime in the early seventeenth century. On the inside bottom are three marks, probably the result of stacking the piece in the kiln. The pot is rather large for a serving dish and functions better as a bowl. It is solidly made.

24. *Picture Shino sewing dish, design of iris. D. 19.0 cm.*
An older associate of mine believes this is "only" a Picture Oribe work, but I am inclined to think it is a product of the Kujiri kilns from sometime after 1615. The overglaze is thinly applied so that the picture shows clearly. Iris designs are rather frequent in Shino pottery. Today, as in times past, irises in graceful bloom are a common sight around Mino during the rains of late spring.

25. *Deep sewing bowl, protruding decorations. H. 8.1 cm.*
This pot is decorated with designs of a cypress fence and grasses and flowers. The color is splendid. Undoubtedly it was used as a serving dish, but it seems better suited as a holder for embers that tea ceremony guests might use to light pipes while waiting to enter the tea room. The buttons of clay stuck onto the sides of the pot are very effective.

26. *Picture Shino, cylindrical sewing dish, designs of willow and bush clover. H. 9.7 cm.*
This product of Ōgaya could easily pass nowadays for a cylindrical teabowl. With a willow design on one side and a bush clover design on the other, it can conveniently be used either in the spring or the autumn. The color is exquisite, and Tōkurō Katō once praised it as the finest coloring he had ever seen. But surely this hue is the work of the flames. No human could have made it on purpose.

27. *Picture Shino sewing dish, design of pampas grass. D. 16.8 cm.*
The superb design takes careful consideration of empty space. The dark blots surrounding the picture of pampas grass look for all the world like a line of bald priests linked together by tendrils of grass.
The piece is well fired; the color is clear. The overall effect is calm and quiet.

28. *Gray Shino sewing dish, design of grasses and flowers. D. 17.2 cm.*
Probably from the Kujiri Inkyo Omote kiln, this fine piece was fired carefully. The design of grasses and flowers is ingratiating. The dish stands on three feet. It is owned by a lover of Shino ware who lives in Niigata Prefecture.

29. *Picture Shino sewing dish, design of autumn grasses. W. 15.8 cm. H. 4.7 cm.*
This was fired either at the Kujiri Motoyashiki kiln or at one of the Ōgaya sites. It is very thin, and the beauty of the lines is exquisite. The potter has used iron-rich *oni-ita* clay for the design. The fine distribution of light and dark is not at all mannered. This dish would be at its best as part of the service at a tea ceremony meal.

30. *Picture Shino serving dish. W. 15.8 cm. H. 5.5 cm.*
The firing has produced a soft effect sure to charm

any connoisseur of Shino tea ceramics. The designs on the rim could represent trees, grasses, or perhaps wisteria flowers. The depth and effect of this dish are intoxicating. Surely it must be the product of an early seventeenth century kiln.

31. *Picture Shino sewing dish. W 15.4 cm. H. 6.3 cm.*

It seems safe to say that this is a dish from the Keichō era (1596–1615), when Furuta Oribe was alive and at his most active. It is a masterpiece on all counts: the design of the picture, the glazing, and the effects of the firing. The shape, called *mokko* (a basket attached to a shoulder carrying pole by a kind of string cradle), is relatively common among serving dishes.

32. *Gray Shino serving dish, design of grasses. W. 16.0 cm. H. 6.0 cm.*

Because it is well fired, the colors emerge clearly in the dish. It imparts a pleasant feeling. Although designed as a serving dish, it can also be used as a bowl because it is so large.

33. *Gray Shino bowl, design of grasses. W. 15.9 cm. H. 3.6 cm.*

The piece was first covered thickly with an iron glaze, then the design was incised with a pointed bamboo tool. This method brings out the white of the feldspathic glaze. The lines are beautiful, the overall effect strong. Such pieces as this clearly illustrate the bold techniques favored by the Momoyama potters.

34. *Picture Shino bowl, protruding decorations. D. 23.8 cm. H. 8.0 cm.*

Thought to be from the Motoyashiki kiln, this bowl was probably made in the first or second decade of the seventeenth century. Although it is not too clear, the picture seems to be a scene of a mountain village in Mino. The boldness of the plate is very much in the style of the Momoyama artists. Not a lot of time was spent on making this pot, but its lack of attention to detail is one of its charms.

35. *Picture Shino sewing dish, design of heron. W. 16.4 cm.*

As they did in the past, herons still come today to the area around Kujiri. This piece, which could just as well be called a plate, has the *mokko* shape (see Caption 31) much favored in the Momoyama period. This is one of a set of five, and only one of these five has a maker's mark, which is not legible.

36. *Picture Shino small four-sided bowl. D. 15.4 cm. H. 6.0 cm.*

The design depicts drying fish nets and a flying bird that appears to be a thrush. It is a nature poem on the mountains of Mino. The lip has been bent inward so that it overhangs—a technique peculiar to this period. Many serving dishes have a similar shape.

37. *Shino Oribe saké server. H. 18.0 cm.*

The forceful shape is first-rate. In its fullness one can see the face of the Momoyama potter. The lid seems to have been fired separately, for the effects left on it from the firing are somewhat different, though outstanding in their own way. On the lid is a tortoises-hell pattern and a three-legged knob. The "hinge" buttons attached to the handle are a wonderful touch.

38. *Plain Shino fish-shaped water dropper; Green Oribe fish-shaped water dropper. L. 10.6 cm.*

These were both made at Kujiri. The green glaze is called Oribe; the cloudy white one is called Shino. Together they are referred to as Shino Oribe.

39. *Gray Shino catfish-shaped incense box, designed by Seison Maeda. L. 6.2 cm.*

The late modern master painter Seison Maeda designed this for fun. It was fired in Toyozō Arakawa's kiln. The painter was born in Nakatsugawa, in Mino, and was inordinately fond of the tea ceramics made in his home district.

40. *Picture Shino ember holder, design of shellfish. H. 8.5 cm.*

This piece features a bold design on a drum-shaped body supported by three feet. It is a rare work and comes from the Motoyashiki kiln in its finest days.

41. *Picture Shino incense box. D. 6.0 cm.*

The design appears to be of grasses. This is one of the finest examples of Picture Shino and as such has always been treated by those interested in the tea ceremony as a treasure. It was made early on by a master potter at Ōgaya. One has to admire the beautiful way in which its thin walls were formed on the wheel.

42. *Plain Shino incense box, by Toyozō Arakawa. H. 3.2 cm.*

This is a work by Toyozō Arakawa, who has been designated a "Living National Treasure." Representative of modern Shino ware, the piece is tranquil, yet tightly structured. The application of the feldspathic glaze is too much for words to describe.

43. *Picture Shino incense box. H. 4.5 cm.*

If the incense box in Plate 41 is of the top rank, this is just one step down. Being from the Ohira kilns, it is not overly smart looking, but it has a strength to it. The manner in which it was made resembles that of the saké pot in Plate 47, and both may well have been created by the same person. Though it is tiny, it has the power and intensity of a much larger piece.

44. *Picture Shino "picture frame" bowl, design of grasses and flowers. W. 13.0 cm. H. 5.0 cm.*

"Picture frame" bowls were apparently fired at the Kujiri Inkyo Omote, Ōgaya Mutabora, and Ohira kilns. They were made with molds. The straightforward, elegant picture complements the outlines of the pot.

45. *Picture Shino deep bowl, design of grasses and flowers. H. 18.0 cm.*

The *mokko* shape (see Caption 31) is decorated with grasses, flowers, and spirals, and supported by three feet. Although the piece is thought to have been made in the Edo period, something of the Momoyama taste can be found in its large size. Its air is restrained.

46. *Picture Shino "picture frame" bowl, design of Chinese buildings and human figures. W. 15.2 cm. H. 3.9 cm.*

The scene depicted here is Chinese in feeling, not at all like the area around Mino. It might just as easily be called Picture Oribe, and was probably made sometime in the third or fourth decade of the seventeenth century. One has to admire the free and stirring quality of the picture, but all in all the pot is rather outside the mainstream of Shino.

Shino Ware for Use in the Tea Ceremony Meal

47. *Shino Oribe saké pot. H. 16.8 cm.*

This saké pot was made at Kujiri sometime after 1615. It also makes a fine water container for the tea ceremony. Though some repairs have been made on the spout, the handle is in perfect condition. The horizontal lines drawn around the bulge at the sides are childish yet charming. At first glance their three-tiered structure looks clumsy, but it is in fact pleasing. The pot is perfect for use during the tea ceremony meal.

48. *Picture Shino shallow bowl. W. 24.8 cm. H. 5.0 cm.*

The design is of trees growing around a brushwood gate. One occasionally sees scenes like this. The firing has brought out the markings on the rim very nicely. Though the plate was designed for serving fish, it would also suit cooked vegetables quite well.

49. *Gray Shino bowl, bracken fern design. D. 26.2 cm. H. 5.7 cm.*

This bowl, with its design of bracken fern made by incising the slip coating, is most unusual. Fire marks serve to give it a forlorn beauty. Its potential uses in the tea ceremony meal are numerous: cooked fish, boiled vegetables, fruit served after the meal....

50. *Plain Shino saké cups. D. 7.1 cm. H. 4.0 cm.*

There is something delicate and different about the way the feet have been trimmed on these cups from the kilns at Ōgaya. Although all five were made together as a set, one of them differs from the others in shape. The charm of these cups lies in their beautiful loneliness and in their elegance, which partakes of the spirit of tea in a way that is hard to put into words. They might be used to serve pickled squid entrails at the tea ceremony meal. One alone would make a nice saké cup for less formal drinking.

51. *Plain Shino saké cups. Left: D. 6.5 cm. Middle: D. 6.8 cm. Right: D. 5.9 cm.*

These three cups were all excavated. Since there are no other extant cups like them, probably very few were made. Or perhaps they were just common household utensils, not highly prized enough to be handed down from one generation to the next. Their various surfaces have a special charm.

52. *Picture Shino deep, square serving dish* (mukōzuke). *H. 7.0 cm.*

This is a superb piece made by some highly skilled potter at Ōgaya in the late 1590s. It is splendid for the tea ceremony meal.

53. *Picture Shino "picture frame" bowl, design of wild grapes. W. 24.0 cm. H. 5.1 cm.*

There are any number of pieces with the same shape, but the design of wild grapes on this bowl is special. It is subtly repeated by the abstract configurations at each of the four corners. The glaze is thin, the workmanship fine. The bowl would be perfect for serving cooked vegetables or cakes.

Shino Teabowls by Contemporary Potters

54. *Picture Shino teabowl, by Shuntō Katō. D. 12.9 cm.*

Shuntō Katō is one of the representative potters from Seto. He does not specialize exclusively in Shino, but true to his reputation, he has created a powerful bowl here. One can see in it a proud desire to uphold

the Seto tradition and not yield to Mino. The artist was born in 1916.

55. *Red Shino teabowl, by Seizō Katō. D. 13.1 cm.*
This potter is the thirteenth generation of the line of Katō Kageaki, one of the founders of pottery at Mino. He operated the Gengetsu kiln at Kujiri and strove to bring about a Momoyama revival. The bowl shown here is a congenial and modern piece. Seizō Katō was born in 1930.

56. *Picture Shino teabowl, by Osamu Suzuki. D. 13.4 cm.*
Osamu Suzuki is one of the most highly regarded of the potters at Mino. He is conscientious about his work and has the natural temperament of a great artist. This shows in his pots. He was born in 1934.

57. *Plain Shino teabowl, by Seisei Suzuki. D. 13.0 cm.*
Seisei Suzuki could be considered the best of the potters from Seto. He does not limit himself only to Shino ware; rather, his interests and great energy cover a wide range of techniques. His style is magnanimous. He was born in 1914 and died in 1990.

58. *Picture Shino teabowl, by Hidetake Andō. D. 13.1 cm.*
The iron underglaze decoration is bold, the glaze on the bowl is thick. The foot is artless but powerful. Andō is the best of the young Shino potters of his generation. His individual style is praiseworthy. He was born in 1938.

59. *Picture Shino teabowl, by Kōzō Katō D. 12.6 cm.*
Although he established his kiln only in the late 1960s, Kōzō Katō's heavy, thick style quickly won a following among connoisseurs. He was born in 1935.

60. *Plain Shino teabowl, by Yasuo Tamaoki. D. 13.2 cm.*
Tamaoki is at the center of Shino activity. He approaches the Shino aesthetic with passion and pleasure. He was born in 1941.

61. *Gray Shino tea bowl, design of flying cranes, by Toyozō Arakawa. D. 12.8 cm.*
The flying cranes on this bowl were made by using a wax resist technique. But the bowl shows far more than Arakawa's skill at drawing.
 Arakawa (1894–1985) was a "Living National Treasure." His discovery of an old Shino kiln at Ōgaya in 1930 was a tremendous contribution to ceramics. His works represent the best of modern Shino.

62. *Picture Shino teabowl, by Tōkurō Katō D. 14.2 cm.*
This strong bowl has been well fired. Its white is eye-catching. Tōkurō Katō is generally conceded to be the best living Shino potter in terms of actual ability. He is a superb rival of Toyozō Arakawa, the two being like dragon and tiger. Born in 1898, Katō is a "man of fire" who exemplifies the true spirit of the Artist.

63. *Gray Shino teabowl, by Rosanjin Kitaōji. D. 10.8 cm.*
The shape of this bowl is similar to the work of Hon'ami Kōetsu, but in every other way—the forceful throwing of the pot, the bold and seamless glazing—it is Rosanjin's own. Since Rosanjin's death (1883–1959), the popularity and critical evaluation of his works have risen with each passing year.

64. *Picture Shino tea bowl, design of Chinese bellflowers, by Naoki Nakayama. D. 12.7 cm.*
Nakayama was one of Toyozō Arakawa's most talented pupils. As this bowl shows, he favors simple drawings on his works. He was born in 1933.

65. *Gray Shino teabowl, by Takuo Katō. D. 128 cm.*
This leader in Mino pottery circles has an intensely devoted involvement in ceramics. His work shows the best of modernist Shino. He was born in 1917.

66. *Picture Shino teabowl, by Kōtarō Hayashi. D. 13.1 cm.*
Born in 1940, Hayashi showed his talent from an early age. His work projects a vigorous self-confidence. His younger brother Shōtarō also showed great promise.

67. *Plain Shino teabowl, by Kenji Kishimoto. D. 12.5 cm.*
Though born in 1938, he quickly showed the characteristics of a great master. Kishimoto's works, pleasing to the eye, give concrete expression to the beauty of Shino.

68. *Gray Shino teabowl, by Toshisada Wakao. D. 13.7 cm.*
Devoted to Shino, where teabowls are supreme, Wakao stood at the forefront of the new potters of his generation. He was born in 1933.

69. *Plain Shino teabowl, by Shuntei Katō. D. 12.0 cm.*
This artist comes from a long line of skilled potters at Akatsu, in the city of Seto. He was born in 1927. The bowl shown here expresses, in a restrained way, the forlorn beauty of last traces of unmelted snow.

ORIBE

Teabowls

1–3. *Black Oribe teabowl, lily design. D. 15.1 cm. Umezawa Memorial Gallery.*

A large bowl, this example is boldly distorted in the "shoe-shape" style thought to gain its name from the wooden shoes worn by courtiers in ancient times. In contrast to the understatement and sobriety of form of early Raku wares, which were the embodiment of Sen no Rikyū's *wabi* taste, this irregular, warped type of bowl symbolizes the aesthetic of his disciple Furuta Oribe. On the glossy surface glazed in black with a lacquerlike sheen, the white lily stem seems to float. The delicacy of the design contrasts with the powerful, masculine shape of the bowl, enhancing its elegance.

4, 5. *Black Oribe teabowl, belfry design (name: "Dōjōji"). D. 13.8 cm.*

Black glaze, fired to a soft sheen, is applied on large areas of this shallow bowl. The bare clay on the wide base is well fired, displaying the typical clay of Oribe ware. One of the sides is splashed with the image of a belfry and waves, the crude lines on the squat shape giving the bowl a faintly humorous quality.

6, 7. *Narumi Oribe teabowl. D. 14.7 cm.*

This bowl, with its red-tinted body, band of green glaze around the rim, white slip, and iron glaze used in the design, is an outstanding example of the most colorful of Oribe wares, Narumi Oribe. This kind of pottery was once believed to have been made in the Narumi area near Nagoya, and although this has proved erroneous, the style retains the name. One of the best of the many existing Narumi teabowls, this example is outstanding for its bold distortion and subtlety of coloring. It is said that the "T" mark inside the foot is that of the tea ware merchant and amateur potter Shimbei.

8–10. *Black Oribe teabowl, Mt. Fuji design. D. 14.6 cm. Tokyo National Museum.*

A stout band rims this large-mouthed bowl with gentle wheel indentations on the body distorted in the shoe-shaped style. The exposed clay around the base is hard and scant in iron, rather resembling Shino *mogusa* clay. The scorched effect on the foot rim probably resulted from the presence of iron in the shelf or support upon which the bowl was placed. The H-shaped mark on the base outside the foot rim is the mark of the maker. The glazing is enhanced by the contrasts where the black glaze overlaps the white beneath. The side showing the latticed image of Mt. Fuji is usually presented as the front of the teabowl, but the opposite side with its silhouette of Mt. Fuji playfully decorated with childlike scribblings has a certain whimsical charm. The white areas are sometimes taken to represent the roof of a house.

11. *Black Oribe teabowl, dango design. D. 12.3 cm. Nezu Art Museum.*

The design, reminiscent of *dango* (skewered rice balls), is cut into one side covered with a lacquerlike layer of iron glaze. The shape is robust and stolid, giving the bowl a character eminently suited to use by warriors of the strife-ridden Momoyama period.

12. *Black Oribe teabowl, geometric design (name: "Shimogare"). D. 14.3 cm.*

This teabowl, although an excavated piece, was obviously used with affection by several generations. The contrasts formed by the white triangular shape and the squared-off black spiral in the adjacent white section give the bowl an ingenuous warmth.

13. *Plain Black Oribe teabowl (name: "Unrin"). D. 14.5 cm.*

Decorated black Oribe is called *kuro Oribe*, while that which is undecorated, as is this example, is called *Oribe-guro*. The bold shape of this piece closely resembles Seto wares, and the brown hues in the black glaze distinguish it among teabowls of this type.

14. *Decorated Oribe pedestaled teabowl (bajōhai type). D. 12.8 cm.*

This bowl was probably originally one of a set of *mukōzuke* food dishes. The pedestaled shape, known as *bajōhai*, is believed to have been inspired by the glass wine goblets brought from the West in the sixteenth century. The delicate rings of iron glaze and drips of thin green glaze enhance the bowl's clear-cut lines and slender elegance.

Serving dishes

15. *Handled dish. D. 23.8 cm. Idemitsu Museum of Arts.*

This dish is rather deep, stepped in around the sides, and affixed with a stout handle. The inside is half covered with a thick coating of green glaze, the remaining half gaily decorated with flowerets in iron glaze. On the outside, the green glaze straddles the dish at opposite ends and covers the handle. The reversal of green glaze and designed portions on the inside and outside demonstrates the careful technique of the maker. As in all Oribe serving dishes of this kind, this example rests solidly on three small feet.

16. *Fan-shaped handled dish. L. 29.3 cm.*

Fan-shaped dishes are rare among Oribe wares, and so are dishes with handles. Fan-shaped handled dishes, then, are even rarer, which makes this piece particularly precious. Unusual not only for its shape, the beauty of its glaze and the delicacy of the pampas grass design on the inside is exceptional, making it one of a handful of Oribe masterpieces.

17. *Square dish, tortoiseshell pattern. L. 23.8 cm.*

This square dish is flooded at one corner with a pool of green glaze, the remaining surface displaying a diagonal stripe pattern scattered with linked hexagonal motifs suggesting the tortoise's shell. The harmony of the three colored portions—green glaze and exposed red clay areas with a belt of white between them—is striking. This, and the example with floral scroll design (Plate 18), are both slab-built dishes with a formality not present in pieces made on the wheel. Alongside the many gaily colored Momoyama ceramic wares, these dishes display an especially impressive strength of form and design.

18. *Square dish, floral scroll pattern. L. 21.5 cm.*

Many Oribe serving dishes, as with this example, are half covered with green glaze and half decorated over the bare reddish clay surface. Moreover, it is clear that red and white clay have been adroitly pieced together, accentuating the lush color of the green glaze and enhancing the contrast with the red-decorated portion. If the shrinkage rate of the two clays is even slightly off, however, the two parts

would separate in the process of firing, making pieces such as this particularly difficult feats of workmanship. Seeming a simply executed, uncomplicated piece at first glance, more careful scrutiny reveals the calculated pains to which the potter went to create this fine result.

19. *Square dish, stripe pattern. L. 22.7 cm. Nezu Art Museum.*

Stripe patterns are found in handcrafts of almost every part of the world, but seem particularly common among the ceramic wares of East Asia. Their variety is infinite, depending on the color combination and width of the stripes. Here, the simplicity of white glaze stripes bordered with iron-glaze lines against the bare reddish clay is set off by the flow of green glaze over one side of the dish. The striped pattern recalls a fine cotton fabric.

20. *Rectangular lidded dish. L. 23.0 cm.*

Slightly underfired, so that the white glaze remained rather pale, this dish is outstanding for its finely executed designs and strength of form accentuated by the sturdy handle and free-flowing stream of green glaze between opposite corners. Dishes of this kind were often made of lacquered wood, decorated with gold, and made into tiered sets. Such tiered boxes were (and are still) used at New Year's or other seasonal celebrations such as cherry blossom viewing and moon viewing parties. This fine piece shows the mark of several generations of affectionate use.

21. *Fan-shaped lidded dish. L. 29.8*

Vessels for eating in the shape of fans or other modeled forms vividly demonstrate the sense of modernity characteristic of Oribe ware. Typical of this group of Oribe wares is the method of glazing that combines a plain green-glazed area with a decorated area featuring textile design motifs taken mainly from the Nō costumes popular at the time. This covered dish eloquently crystallizes the sophistication of the arts of the Momoyama period.

22. *Fan-shaped lidded dish. L. 28.4 cm. Umezawa Memorial Gallery.*

Because the lid and bowl must be fired separately, these covered dishes present the potter with a particularly difficult challenge. Many dishes originally intended to have lids are without them. This piece is exceptional for the delicate green hue of the glaze and the detailed workmanship on the cover, featuring radiating and arcing incised lines, combed areas, designs in iron glaze, swaths of green glaze, and a painstakingly modeled handle in the shape of bamboo. The inside of the dish, no less carefully executed, greets the eye with a bright pool of green glaze and scattered flower designs.

23. *Square lidded dish. L. 21.2 cm.*

Oribe ware is particularly rich in the multiplicity of its designs, including animal, human, and abstract motifs of all kinds. Even amid this variety, this dish is unusual. Its motif of a waterwheel submerged in a stream is common in many of the traditional crafts, including textiles and gold-decorated lacquer ware, and is often seen in the paintings of the Rimpa school. Among ceramic wares, however, this is perhaps the only example where the design is so effectively done inside a lidded dish. The amusing figure of a mantis perched pertly on a spray of willow etched in a splotch of iron glaze inside never fails to fascinate.

Mukōzuke Food Dishes

24. *Square indented* mukōzuke *food dishes. L. 12.4 cm.*
This type of Oribe *mukōzuke* is made with a mold. At close look, impressed traces of the cloth used to facilitate separation of the pots from the mold are visible on the inside. The pieces are distinctive for their design and the peculiar shape.

25. *Plover* mukōzuke *food dishes. L. 13.8 cm.*
Free forms like these flying birds reflect the appreciation of the Momoyama potter for the beauties of his natural environment. The decorations painted between the green-glazed wings have a modern touch of abstraction that recalls the paintings of Paul Klee.

26. *Rhomboid* mukōzuke *food dishes. L. 20.3 cm.*
The Yashichida Oribe kiln, not far from the Ōgaya kiln that produced many famous Shino pieces, was known for pottery with the classic elegance of Kyoto fashion. The dishes are thin-walled, and the delicately carefree designs are mingled with a stray comet of blue glaze and designs in light brown as an intermediary color. The patterns are uninhibited, giving the pieces a very contemporary air.

27. *Crescent-shaped* mukōzuke *food dishes. L. 15.8 cm.*
The crescent-moon shape painted with delicate designs of pampas grass skillfully and subtly links these two images paired in classic Japanese poetry. The streaks of blue glaze splashed randomly in seeming disregard of the grass design augment the special fascination of the pieces. The set is among the most famous made at the Yashichida kiln.

28. *Handled* mukōzuke *food dishes. Hatakeyama Collection.*
Even the most avid devotee of old Oribe is rarely fortunate enough to see a collection of handled *mukōzuke*. This group, bringing together five examples, each different in shape and decoration yet sharing the same overall character, may well be called the king of *mukōzuke* sets.

29. *Openwork* mukōzuke *food dishes. H. 11.3 cm. Umezawa Memorial Gallery.*
Their walls cut out in decorative slits, these dishes were probably used to serve small mounds of food, which probably reached only to the point where the green glaze begins. This kind of deep *mukōzuke*, perforated to reveal glimpses of the delicacy within, are called *nozoki* or "peep-through" dishes, and they are particularly rare.

30. *Boat-shaped* mukōzuke *food dishes. L. 20.8 cm.*
Pleasant to look at as well as to use, this set is typical of Oribe *mukōzuke*. Each is dipped fore and aft in green glaze, the white of their center portions scattered with cherry blossoms.

Water Containers and Tea Caddies

31. *Tea caddy. H. 11.2 cm.*
A tea container in the classic shape, the cascade of overglaze and the design of dangling persimmons hung to dry make a suitably harmonious combination.

32. *Eared Mino Iga water container. H. 18.6 cm.*
Emulating true Iga ware, which is characterized by a

reddish tinge, scorching *(koge)*, and glasslike flows of natural ash glaze, iron glaze has been dripped on in random fashion on this piece. Its shape is strong like the torso of a country warrior. This is one of the best examples of Mino Iga ware pieces that have been preserved.

33. *Bucket-shaped tea caddy. H. 10.6 cm. Nezu Art Museum.*

Probably this piece was originally part of a set of small *mukōzuke* food dishes. A faithful representation in detail of a real bucket, it is impressive for the uncontrived, yet regular stripes around its body.

34. *Eared Mino Iga water container. H. 20.3 cm.*

A single drip of iron glaze down one side of the purse-shaped body accentuates the effect of the jar's unconventional form.

Vases, Incense Boxes, Incense Burners

35. *Vase, stripe pattern. H. 30.2 cm. Umezawa Memorial Gallery.*

This piece is praised for its stripe pattern, evoking the markings on a Chinese diviner's block. The mouth and foot of the vase are of similar shapes, and the unusual abstract decoration makes it a distinctive piece among Oribe vases.

36. *Incense burner with handles. H. 8.8 cm.*

The green glaze generously applied over the upper portion and handles of this incense burner is of an unusual deep hue. It has an endearing air of feigned simplicity with its tracings of Chinese divination symbols and its stout and somewhat high legs.

37. *Incense box, scroll pattern. H. 4.1 cm. Idemitsu Museum of Arts.*

This Oribe piece lacks the typical green glaze, its squat body is entwined with a scroll pattern outlined in lines of black iron glaze. The bold proportions of the decoration are well suited to the piece's placid form.

38. *Square incense box, human and bird figures. H. 4.3 cm.*

Also without green glaze, this piece is amusingly decorated on one side with a scarecrow figure in a large straw hat, looking like a Jizō guardian statue, and a sketch of a bird on another. Its lid is affixed with a raised button handle surrounded by four small circular designs, the final touches to its diminutive charm.

39. *Pinnacled incense box (name: "Shigure"). H. 5.4 cm. Idemitsu Museum of Arts.*

The lid of this incense box is tapered in the shape of a simple wayside shrine *(tsujidō)*, only the symbolic petals wreathing the tip being dipped in green glaze. This hand-modeled example has much more of the exotic flavor of Momoyama period craftsmanship than other *tsujidō* incense cases made in molds.

40. *Incense box, eggplant shape. H. 7.2 cm.*

Unlike the formal propriety of Chinese-style incense containers, this example has a whimsical touch, with glaze capping only the stem and calyx of the eggplant. It displays a very Japanese sense of human warmth, yet with elegance. Three supporting feet are cut into the base.

Saké Drinking Vessels, Ewers, Jars

41. *Bottle, diadem and grapevine design. H. 24.9 cm.*

This is perhaps the largest existing piece among old Oribe. One side is painted with designs that could be either hanging persimmons or dangling diadems and the other with leaves of a grapevine. The serene design is well suited to the broad, solidly built shape, bearing elegant testimony to the wealth and grand style of the Momoyama age. The characteristics it shares with the ship's bottles (*funa-dokkuri*) of Bizen give it added interest.

42. *Monochrome Oribe saké cups. D. 6.0 cm.*

Among Mino wares, saké cups are all hexagonal and display three types of glazing—green, iron, and Yellow Seto glaze. Today these pieces are included among saké drinking vessels, although when originally made they were known as *choku*, a type of small *mukōzuke* food dish.

43. *Ewer with handle. H. 30.9 cm. Nezu Art Museum.*

Displaying a harmonious blend of all the Oribe colors—green, white, black, and red—this outstanding piece startles even the accomplished connoisseur. All the colors are fresh and distinct, and detail has not been neglected, as in the continuity of lines cut into the rim, the lid's grip, and along the handle.

44. *Saké flask, spatterdock design. H. 19.5 cm.*

The vast majority of Oribe saké flasks are of this tall type, and most, having been found in excavation sites, have needed repairs on the neck portion. This one is no exception. The body is painted with wild spatterdock weed in iron, and the neck and shoulders are covered with a bluish glaze like a sky overhead.

Novelty Items

45, 46. *Pipes. Plate 45, L. 12.5–13.4 cm.; Plate 46, L. 7.6–9.6 cm.*

Some are completely glazed in green, some with iron glaze, and others combine green glaze with iron decorations; but all evoke the foreign flavor of pieces influenced by the early exposure to Western culture. Some have a small hole at one end to facilitate cleaning with twisted-paper string. All are excavated pieces that required repair. A most rare example with a monkey clinging to the side is included.

47. *Candleholder figurine. H. 23.4 cm. Umezawa Memorial Gallery.*

Of special interest among Oribe wares are those influenced by the exposure to the foreign—specifically Portuguese—culture introduced to Japan in the sixteenth century. Prominent examples are the tall glass goblet-shaped *mukōzuke* food dishes and teabowls with the cross used as a design motif. Only about three or four of these candleholders representing the figures of foreigners exist. Since the Portuguese certainly never came as far as the mountains of the Mino area, these pieces are believed to have been especially ordered by Oribe or someone of his acquaintance who was himself in contact with the foreign visitors. One cannot help admiring the humor and exotic flavor so skillfully shown in the facial expression and attire of these figures.

Writing Implements

48. *Monochrome Oribe inkstone, water-flower design. L. 16.8 cm. Umezawa Memorial Gallery.*

These Oribe examples are the only ceramic inkstones

from the Momoyama period save for a rare piece of Bizen. Spatterdock flowerets are scattered in the stylized water pattern on this inkstone, a decoration well suited to the function of the implement. A sturdy, masculine piece, it displays the subtle grace and refinement typical of Momoyama crafts.

49. *Monochrome Oribe inkstone, squash-flower design. L. 17.0 cm. Tokyo National Museum.*

The design on this inkstone is in low relief. These implements were more highly fired than serving utensils, but the piece shows the signs of considerable use. Note the hole in the center of the squash at the right side; water put into this hole beforehand could be run onto the surface by simply tipping the inkstone.

50. *Fish-shaped waterdroppers. Large, 11.1 cm.; small, 9.0 cm.*

These implements used to supply water for grinding ink are called *suiteki* or *kenteki*. The Old Seto ware of the Kamakura and Muromachi periods include tiny jars called *suiteki*. These charming fish-shaped examples are complete with scales, fins, and eyes skillfully incised with a slender bamboo tool in a simple yet extremely lifelike manner.

51. *Monochrome Oribe flower-stamped waterdropper. H. 2.8 cm.*

In the small jar shape of the Old Seto type covered with green Oribe glaze, this piece displays the kinship of Oribe with the ancient Seto wares.

Modern Oribe

52. *Monochrome Oribe plate. D. 49.1 cm. Hidetake Andō. (b. 1938)*

Andō's standard works employ iron, Shino, and Oribe glazes, and this example is outstanding for the brilliant depth of the Oribe green.

53. *Monochrome Oribe dish, iris design. D. 29.7 cm. Seizō Katō. (b. 1930)*

The potter, whose kiln is located near the ancient Motoyashiki kiln, possesses profound knowledge of the old wares. This is a fine example of the ancient techniques applied to contemporary wares.

54. *Monochrome Oribe plate. L. 32.3 cm. Yasuo Tamaoki.*

Made by the slab method and decorated with a heavy combing texture, this piece displays great forcefulness.

55. *Narumi Oribe plate. L. 40.7 cm. Toshisada Wakao. (b. 1933)*

The Miro-like design gives this plate its abstract, modern air. It is an imaginative piece, superimposing a new dimension on traditional techniques.

56. *Handled dish. D. 23.8 cm. Kiheiji Takiguchi.*

The wiggly handle and stepped-in sides demonstrate the fine craftsmanship in this work. It admirably evokes the vitality of the classical Oribe pieces.

57. *Monochrome Oribe plate. L. 40.2 cm. Osamu Suzuki. (b. 1934)*

This is typical of the heroic proportions and exuberant quality of Suzuki's works; its strong form is worthy of the boldest Momoyama period warrior.

58. *Black Oribe teabowl. D. 14.6 cm. Mitsuemon Katō.*

Sometimes unpleasant, the shoe-shaped form seems natural and well balanced in this piece.

59. *Narumi Oribe* mukōzuke *food dishes. W. 16.2 cm. Kōtarō Hayashi.*

The white-glazed pattern, like a web of paddy-field footpaths, forms a striking contrast with the deep green and reddish glazes.

60. *Oak leaf-shaped dishes. L. 23.8 cm. Rosanjin Kitaōji. (1883–1959)*

This famous potter, known for his eclectic work, often uses both Oribe and Shino glazes. These leaf-shaped pieces are monochrome green Oribe, outstanding for their refined proportions, vigorous modern forms, and the subdued glow of color.

61. *Handled dish. L. 28.5 cm. Tōkurō Katō. (1897–1985)*
A well-known potter of Shino, Oribe, and Seto wares, this is among Tōkurō's finest Oribe works. The fine contrast between the luster of the blue-green glaze and the decorated portion of the dish makes it memorable.

62. *Handled dish. H. 16.4 cm. Takuo Katō. (b. 1917)*
This example typifies the ceramic tradition of the Katō family, whose work is carried on by Takuo's father Kōbei and his son Hirohide, both leaders in the production of Mino ceramics.

63. *Narumi Oribe teabowl. D. 13.0 cm. Tadashi Sasaki. (b. 1922)*

Sasaki is famous for both Oribe and *tenmoku*-style pieces. This bowl combines an unpretentious shape with simplicity in its fiddlehead fern motif.

64. *Monochrome Oribe flower vase. H. 26.3 cm. Shuntei Katō. (b. 1927)*

Shuntei is the second generation of a branch of the famous potters of the Sakusuke Katō family and a leading Seto potter. The ridged form is a fresh touch among the works of modern Oribe.

MINO KILN SITES FOR SHINO WARE

1. Yashichida
2. Iwagane
3. Kamashita
4. Mutabora
5. Naka
6. Sengen
7. Yūemon
8. Seidayū
9. Yamanokami
10. Takane-nishi
11. Takane-higashi
12. Onada
13. Yamanokami
14. Kamane
15. Hachiman
16. Hinata
17. Akasaba
18. Kamane
19. Motoyashiki
20. Seianji
21. Inkyoyama-omote
22. Inkyoyama-ura
23. Ōtomi
24. Jōrinji
25. Entogawa
26. Seki
27. Kujiri
28. Fukasawa
29. Ikuta
30. Tōshirō
31. Nishiyama
32. Kamabata
33. Kamabora
34. Dachi
35. Ikeda

MINO KILN SITES FOR ORIBE POTTERY

1. Kukuri
2. Sengen
3. Yashichida
4. Iwagane
5. Naka
6. Kamashita
7. Mutabora
8. Yoshiemon
9. Seidayū
10. Kamasaka
11. Yamanokami
12. Takane-nishi
13. Takane-higashi
14. Takanegamasawa
15. Yamanokami
16. Onada
17. Kamagane
18. Kokeizan Maeyama
19. Hachiman
20. Hinata
21. Akasaba
22. Kamagane (Kujiri)
23. Motoyashiki
24. Seianji
25. Inkyo-ura
26. Inkyo-omote
27. Ōtomi-nishi
28. Ōtomi-higashi
29. Jōrinji
30. Entogawa
31. Seki
32. Kujiri
33. Fukasawa
34. Tōshirō
35. Nishiyama
36. Kamabata
37. Kamabora
38. Ichinokura
39. Myōto
40. Kasahara
41. Kamagane
42. Tsumaki
43. Guminoki-bora
44. Kamashita
45. Gōnoki

志野と織部
CLASSIC STONEWARE OF JAPAN
SHINO AND ORIBE

2002年9月6日　第1刷発行

著　者　　黒田領治／村山武
訳　者　　ロバート・ヒューイ／リン・リッグス
発行者　　畑野文夫
発行所　　講談社インターナショナル株式会社
　　　　　〒112-8652　東京都文京区音羽 1-17-14
　　　　　電話　03-3944-6493（編集部）
　　　　　　　　03-3944-6492（営業部・業務部）
　　　　　ホームページ　http://www.kodansha-intl.co.jp
印刷所　　光村印刷株式会社
製本所　　牧製本印刷株式会社

落丁本・乱丁本は、小社業務部宛にお送りください。送料小社負担にてお取替えします。なお、この本についてのお問い合わせは、編集部宛にお願いいたします。
本書の無断複写（コピー）、転載は著作権法の例外を除き、禁じられています。

定価はカバーに表示してあります。

Copyright © 2002 by Kodansha International Ltd.
Printed in Japan
ISBN 4-7700-2897-0